TWILIGHT GARDEN

MARIA TROLLE

GIBBS SMITH

TO ENRICH AND INSPIRE HUMANKIND

26 25 24 23 17 16 15 14

Twilight Garden
Illustrations © 2017 Maria Trolle.
www.mariatrolle.se
Instagram: @maria_trolle
Blog: www.trollesgarden.se

Gibbs Smith
P.O. Box 667
Layton, Utah 84041

1.800.835.4993 orders
www.gibbs-smith.com

ISBN: 978-1-4236-4706-5

Twilight Garden is also available as an Artist's Edition and Postcards!

THIS BOOK
BELONGS TO:

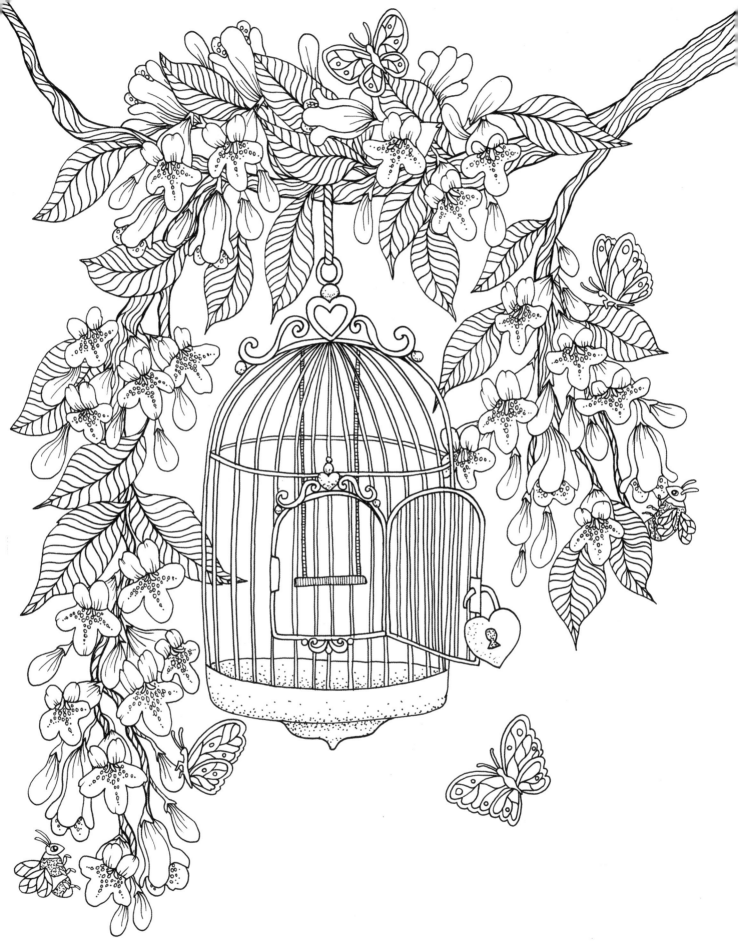

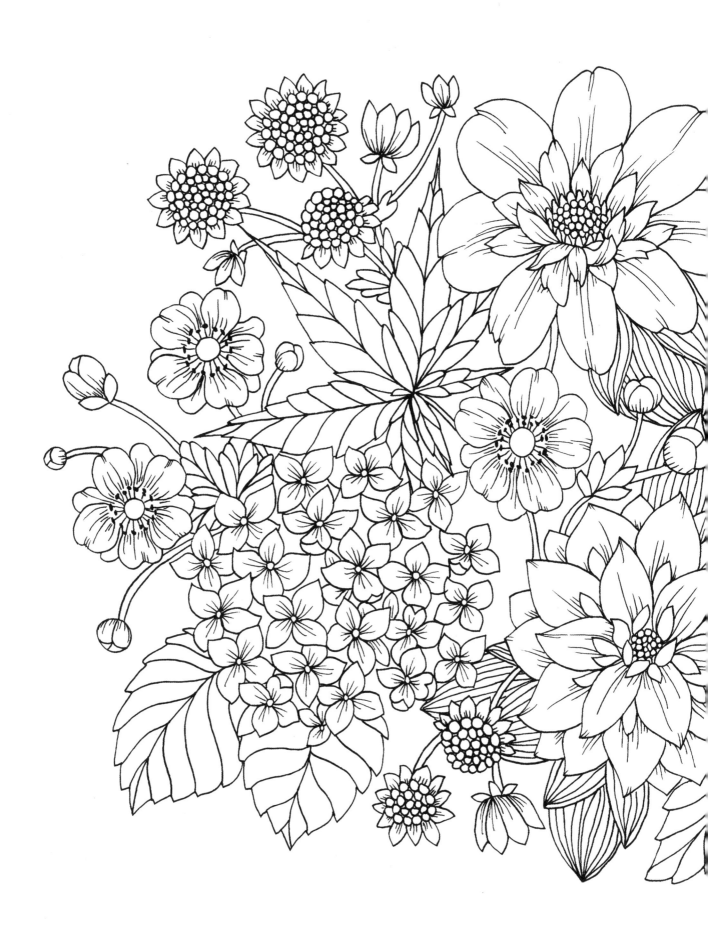

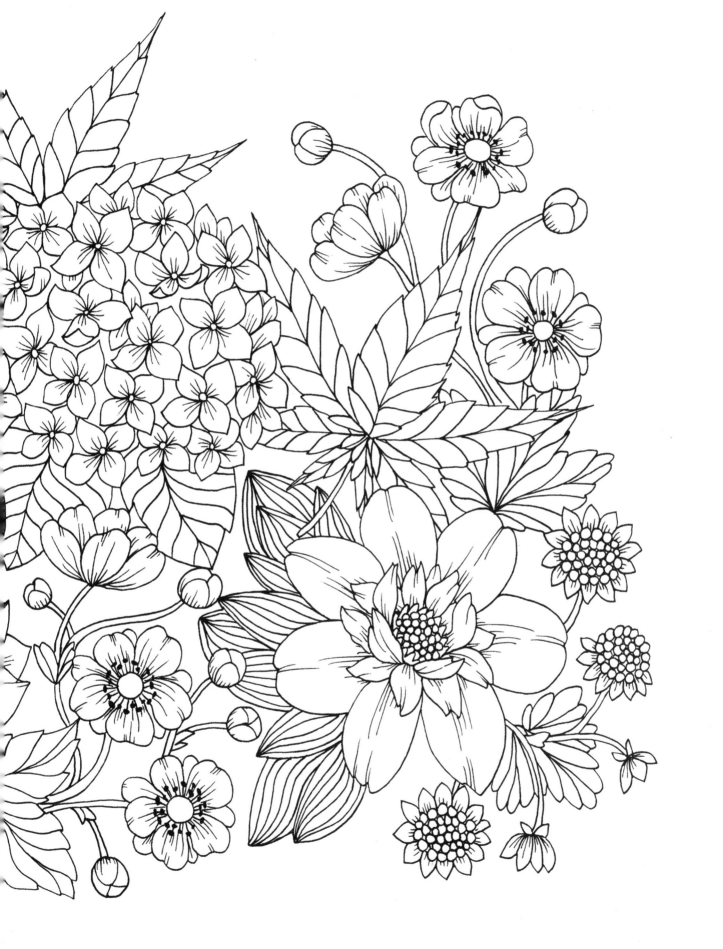

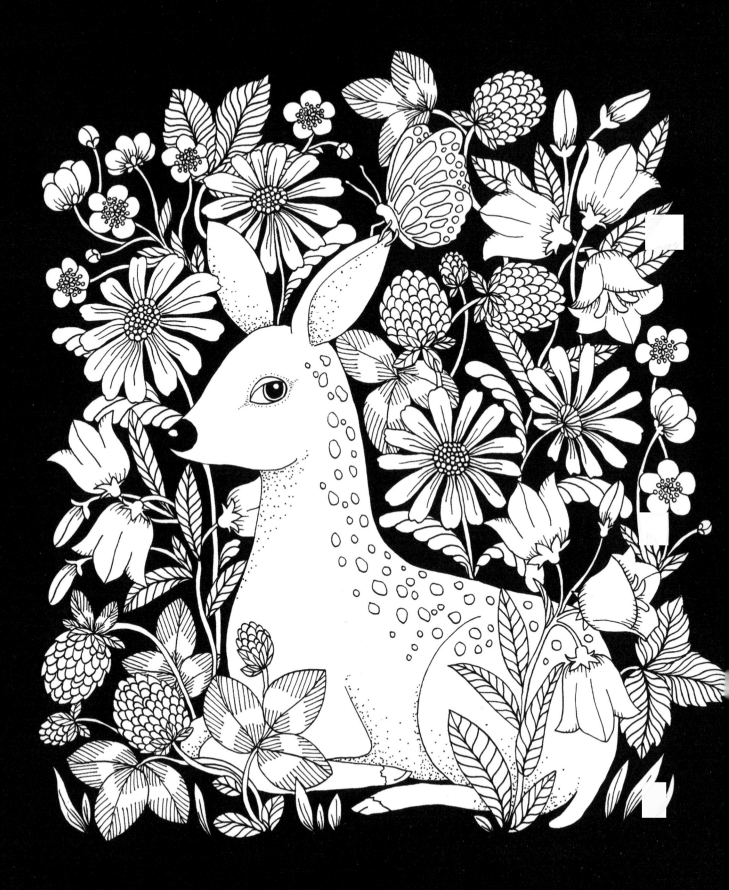

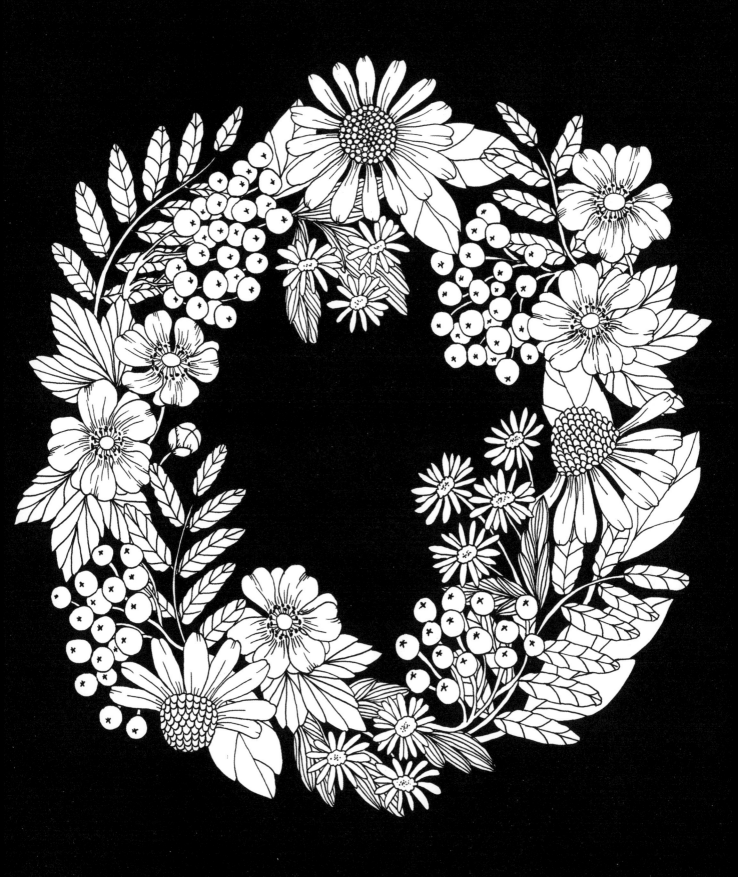

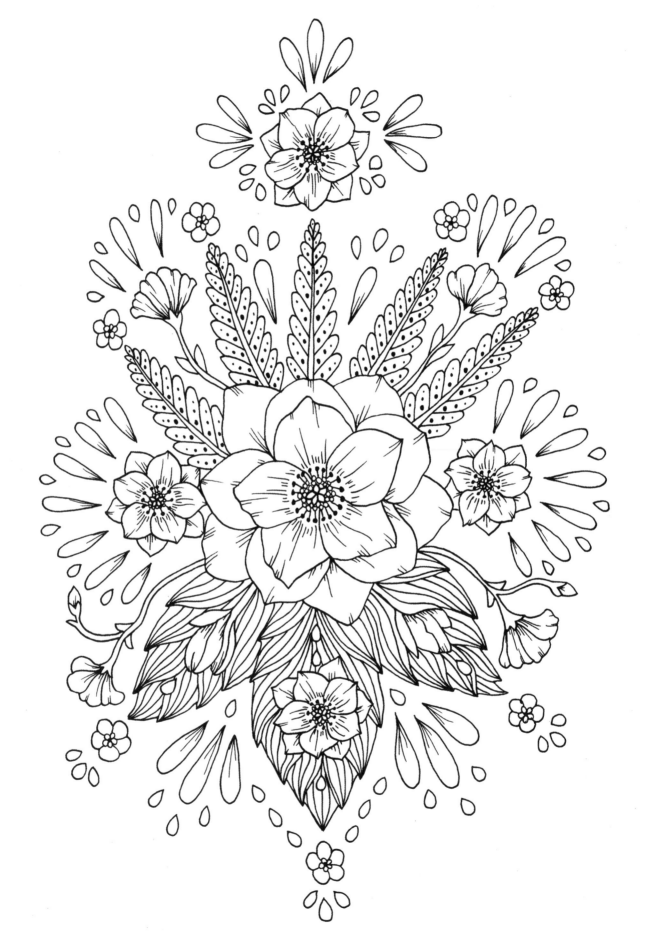

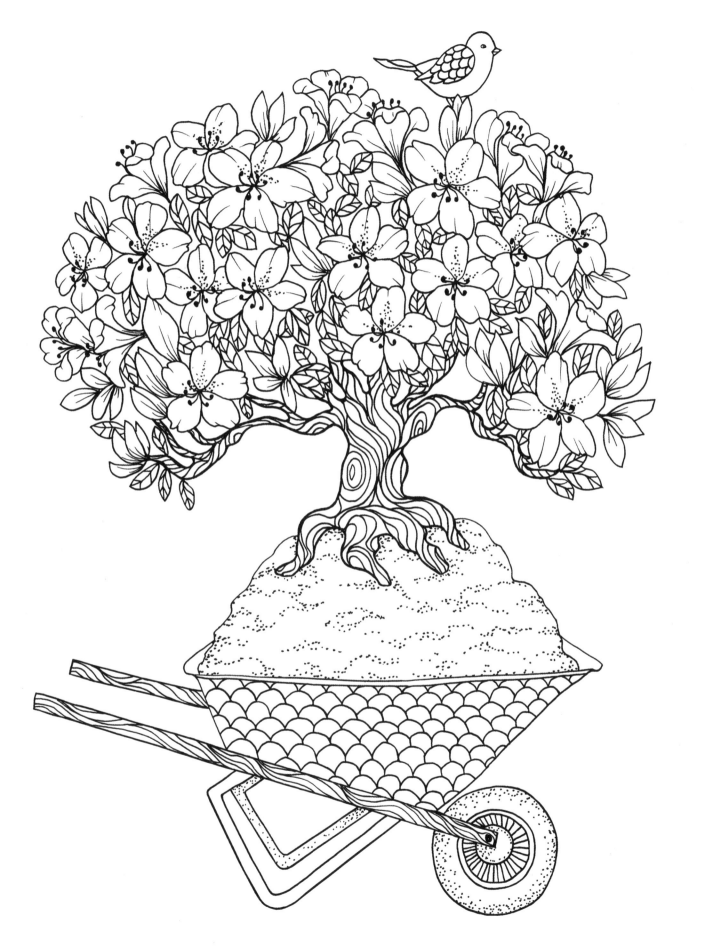

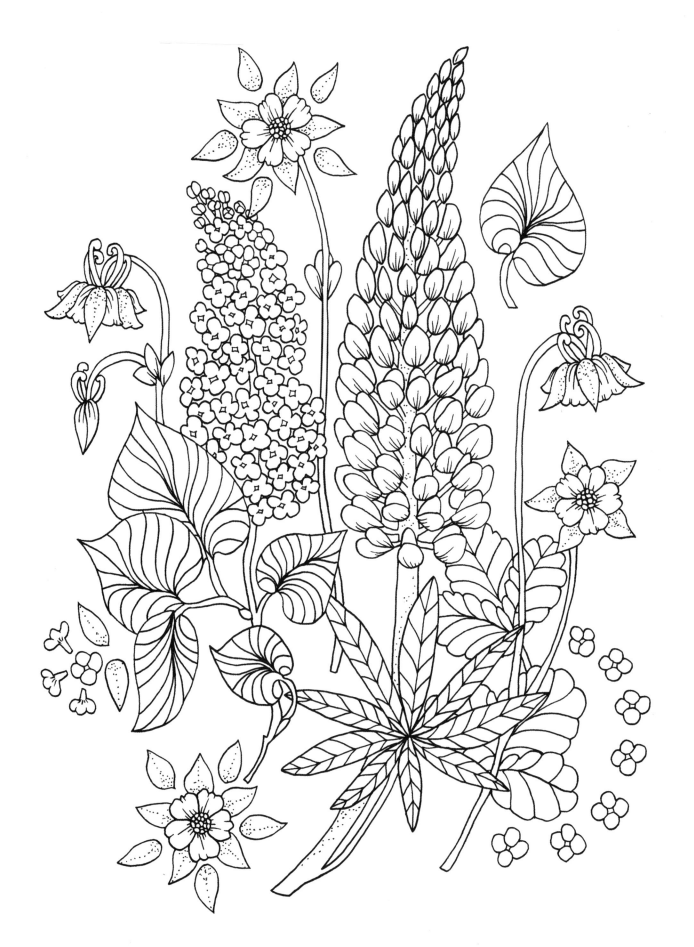

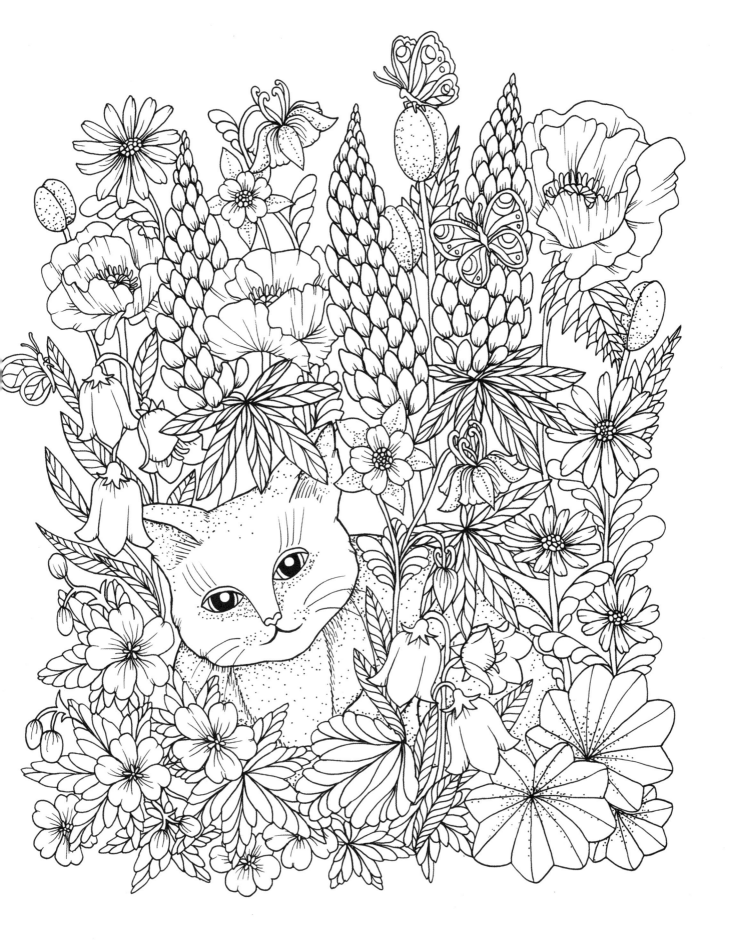

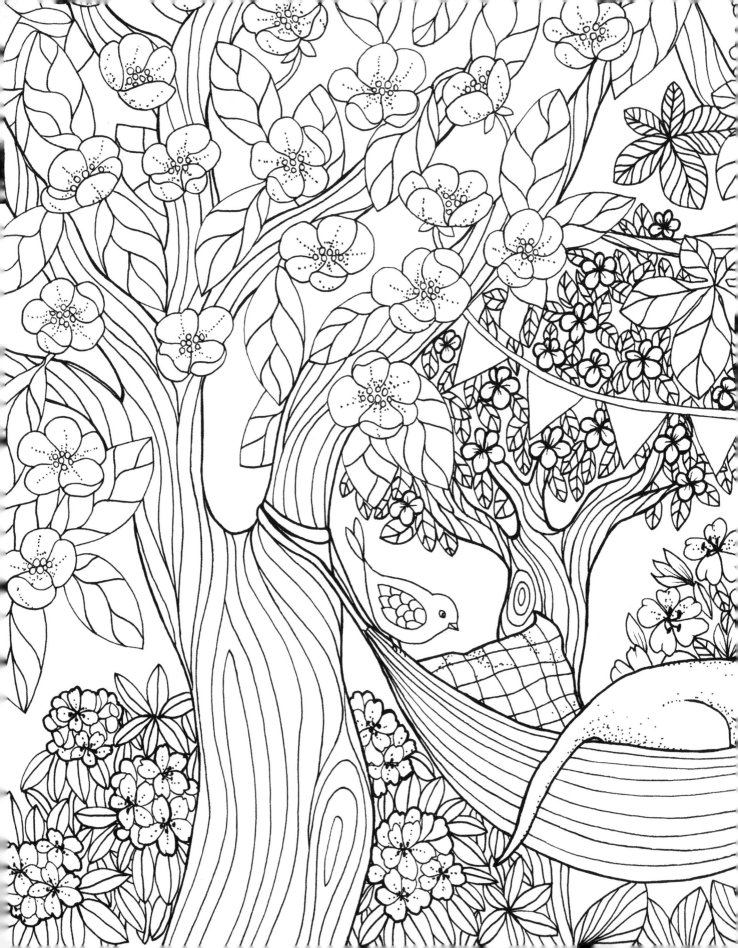

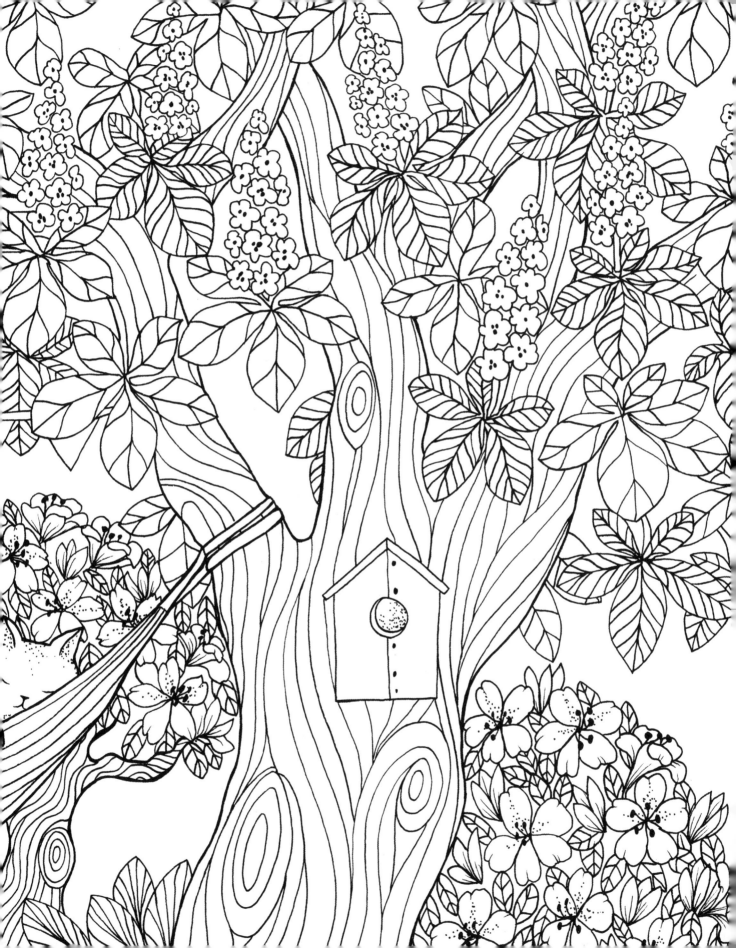

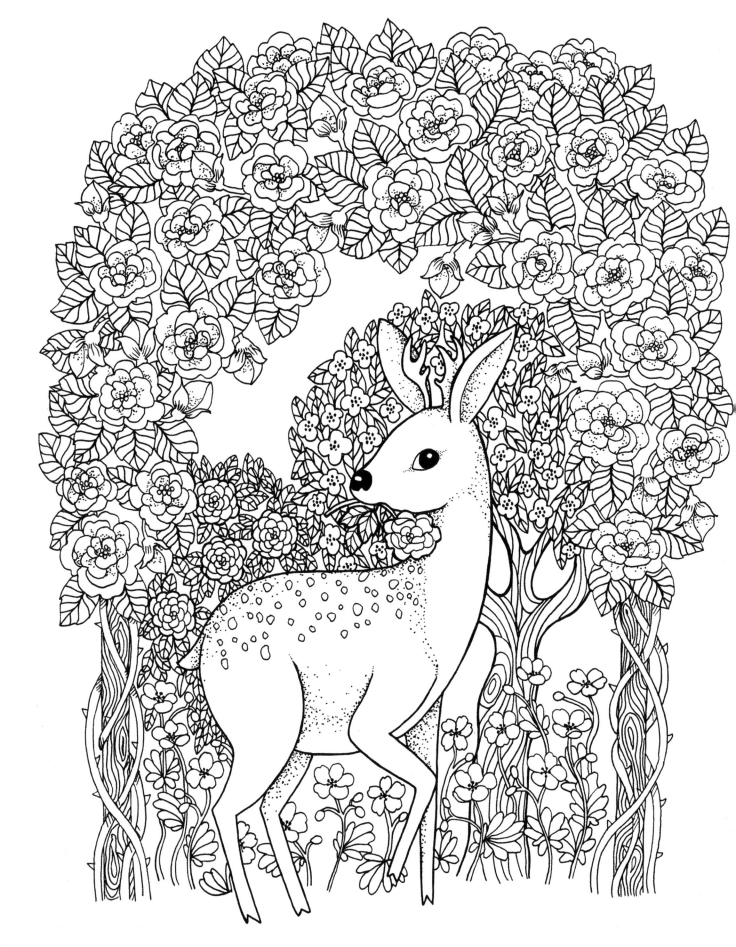

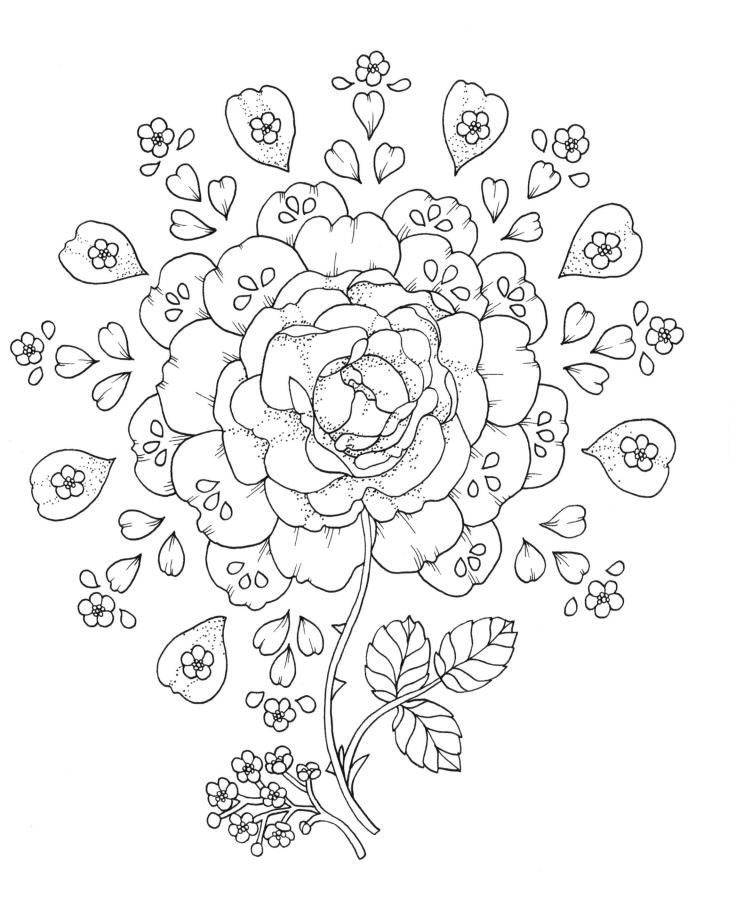

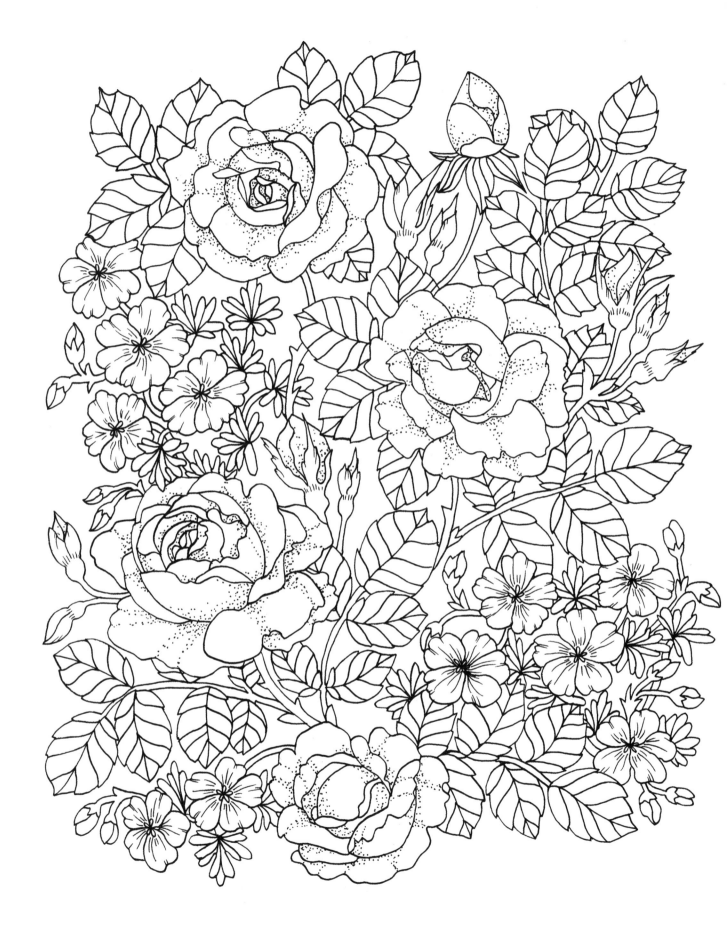

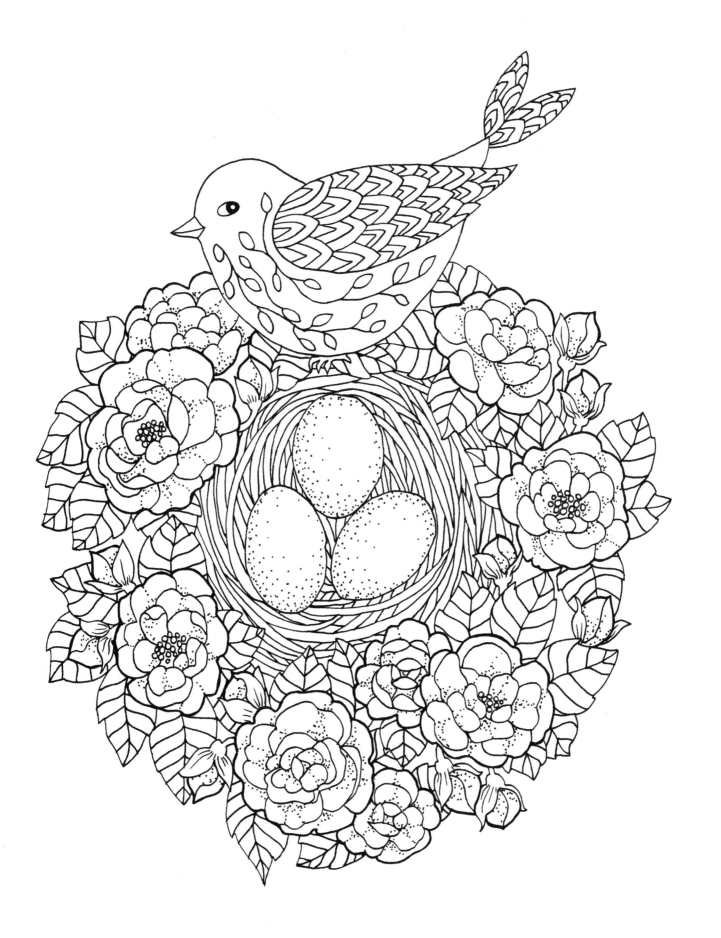

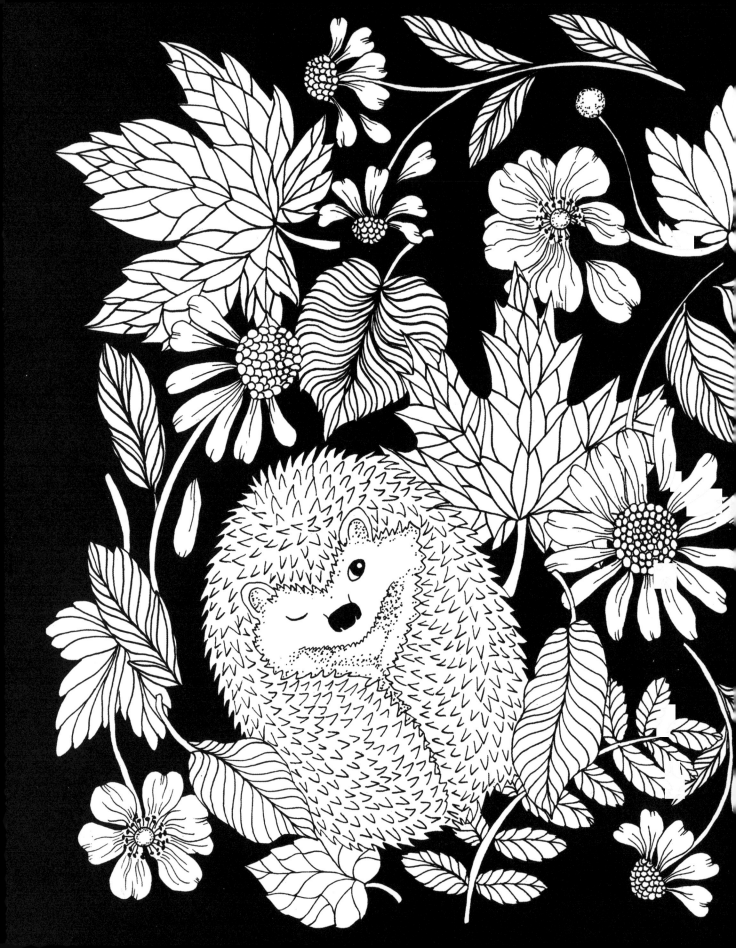

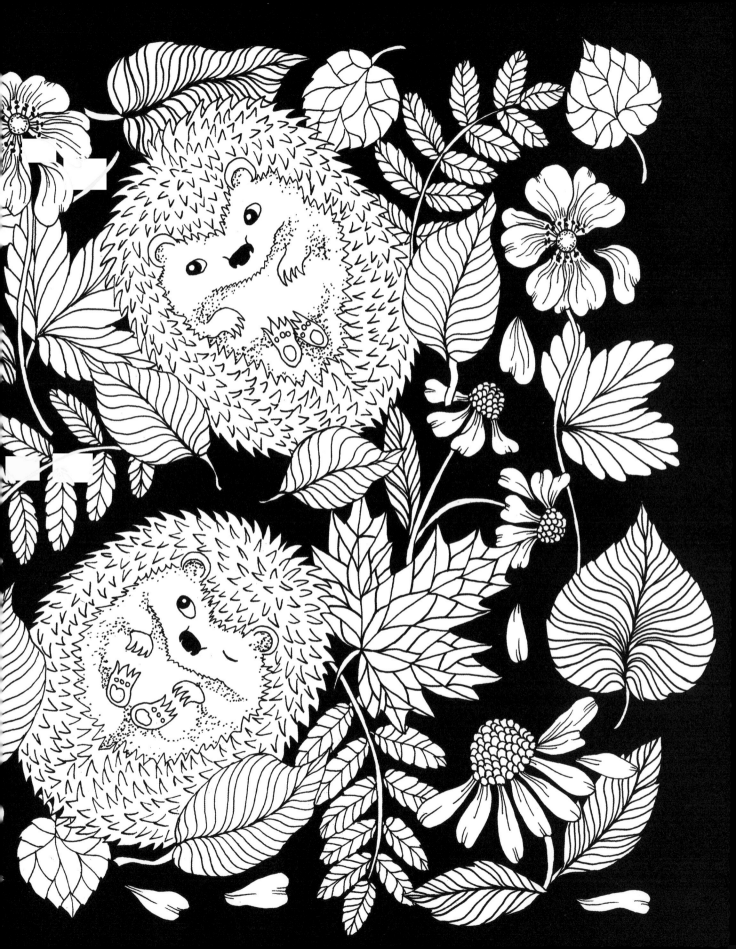

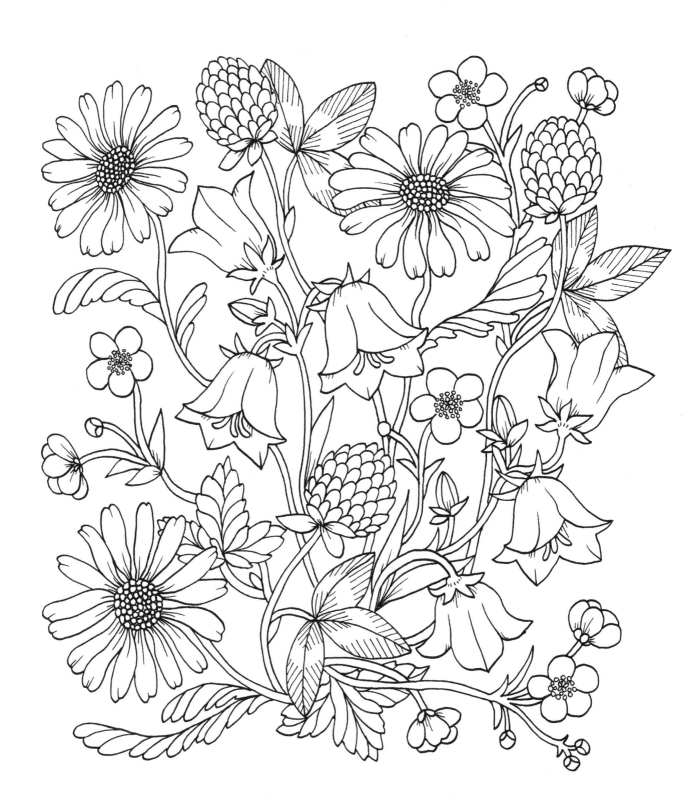

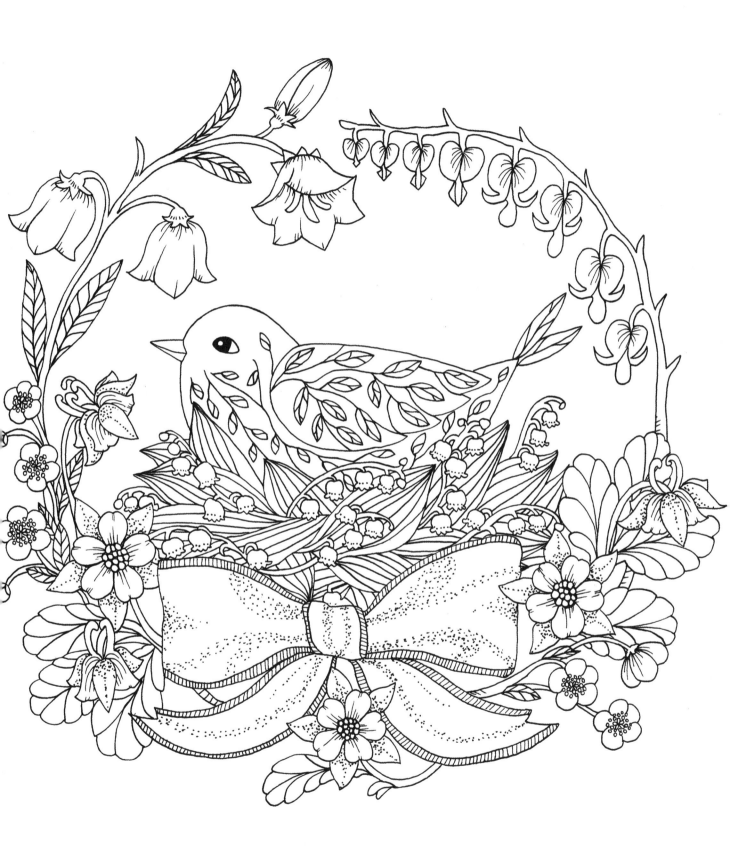

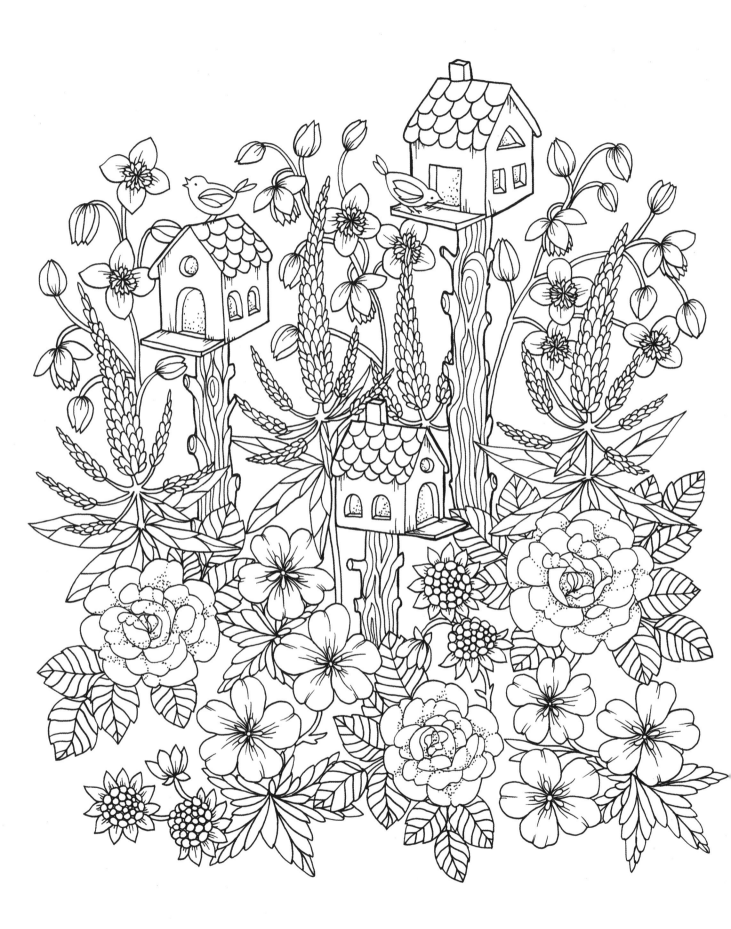

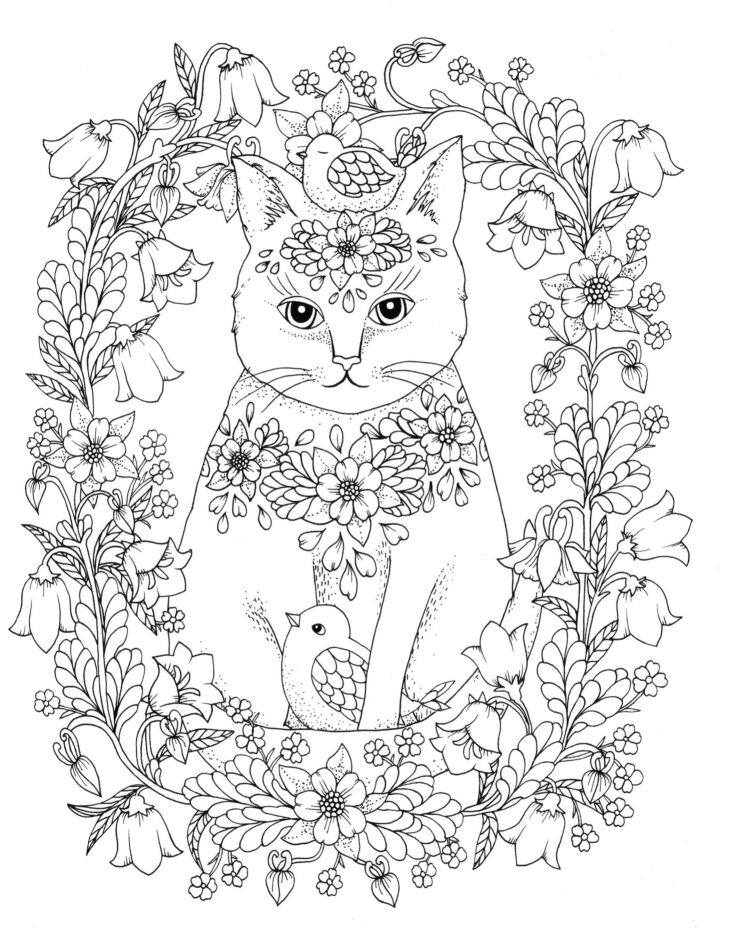

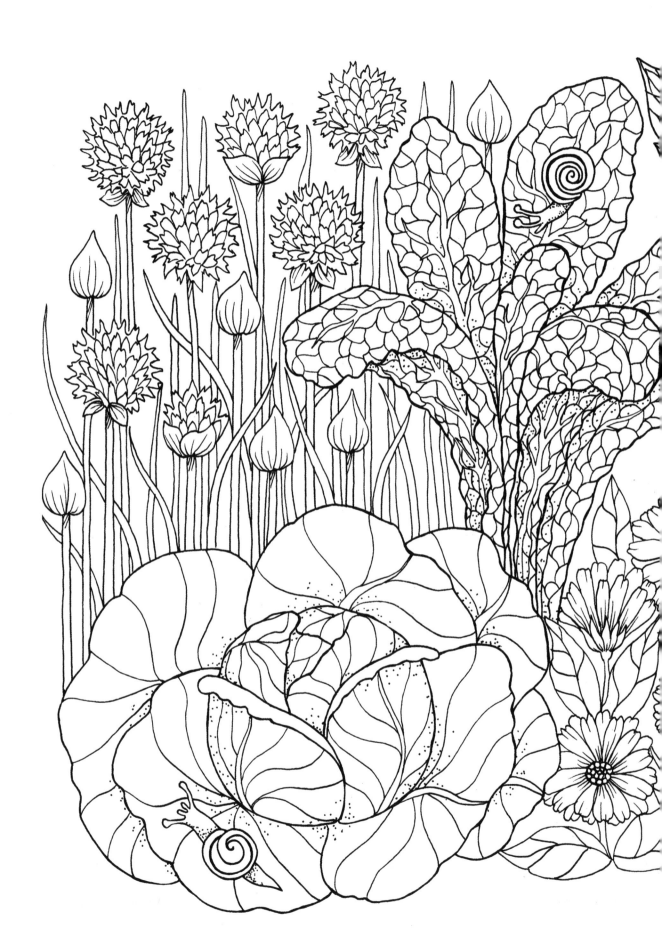

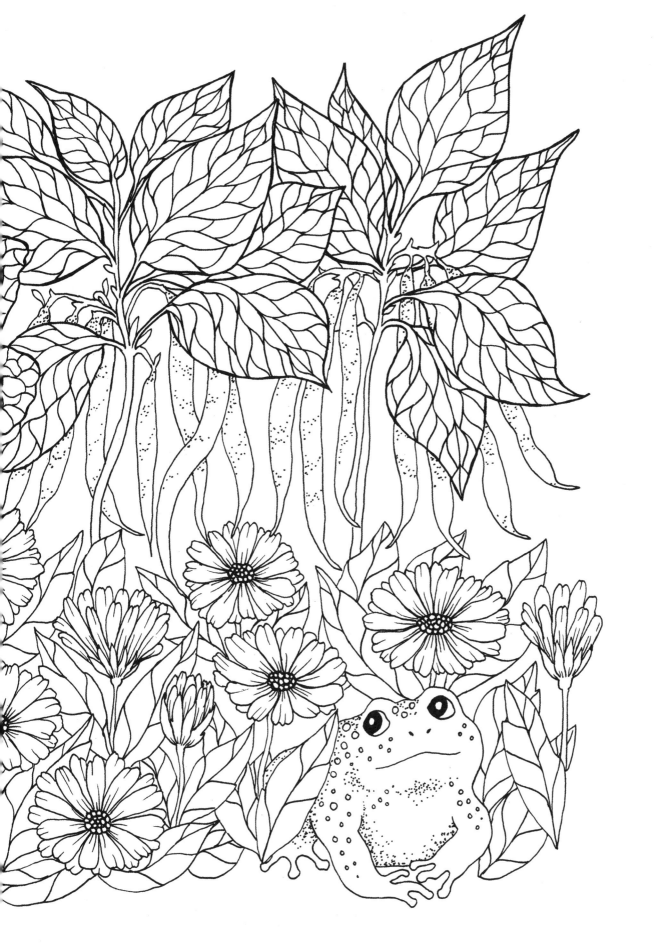

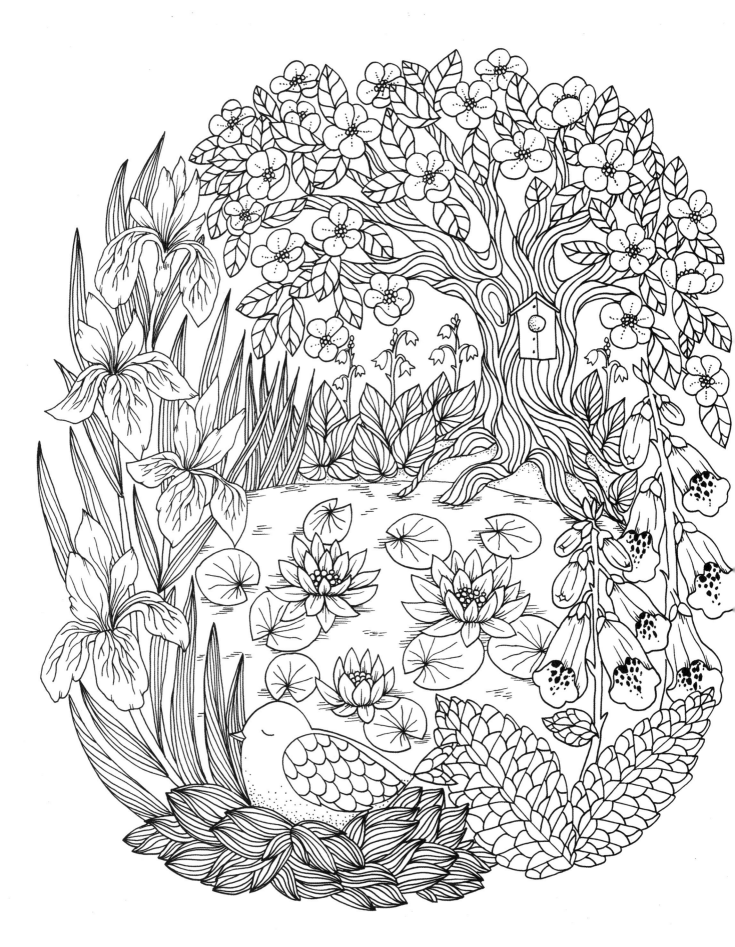

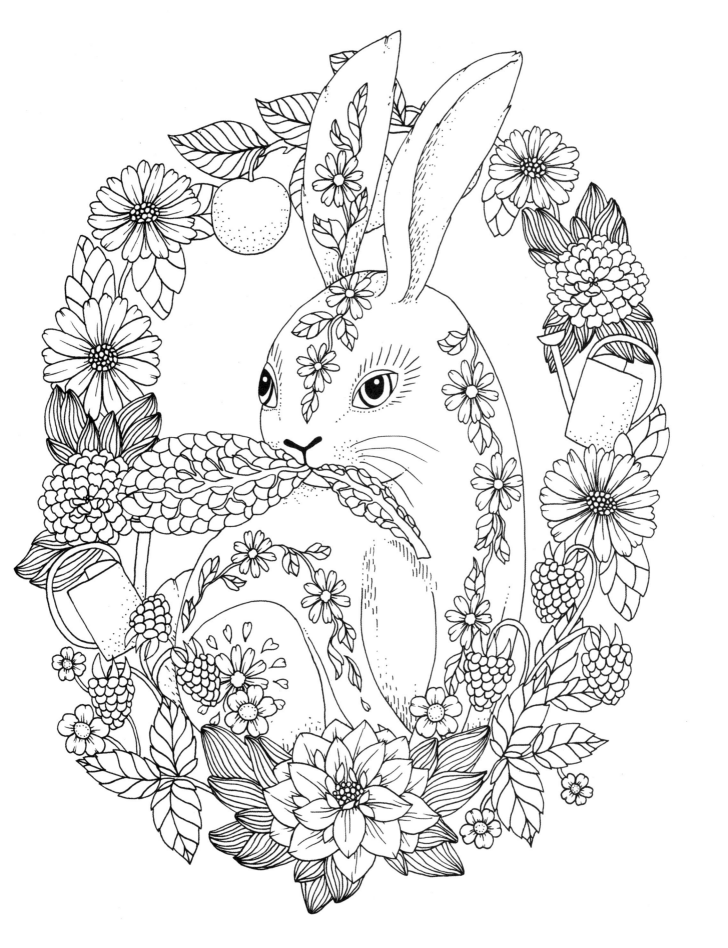

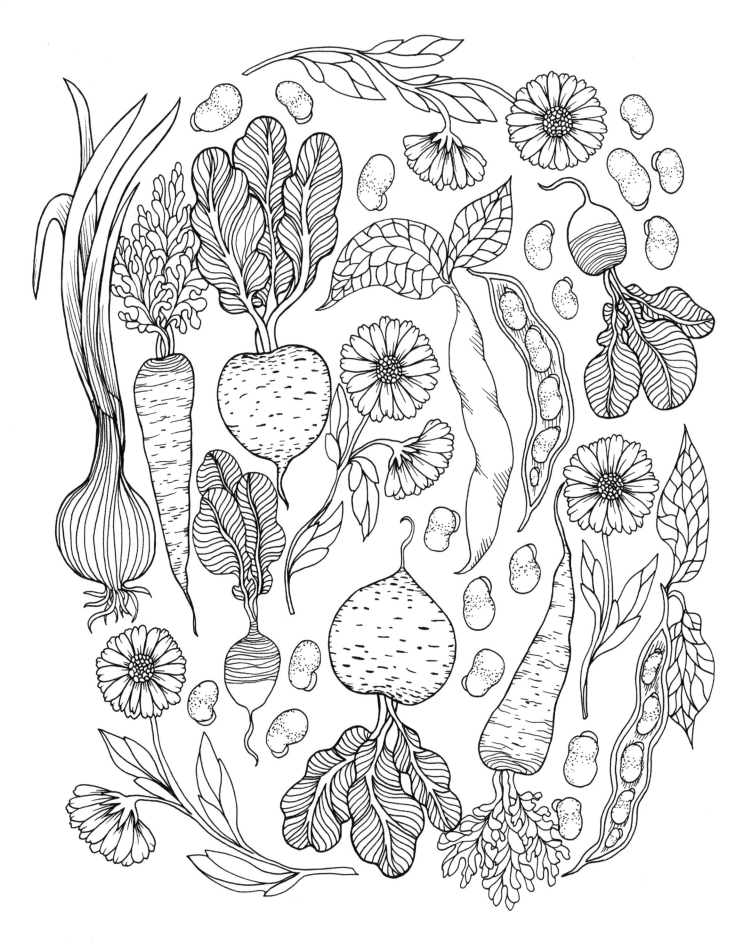

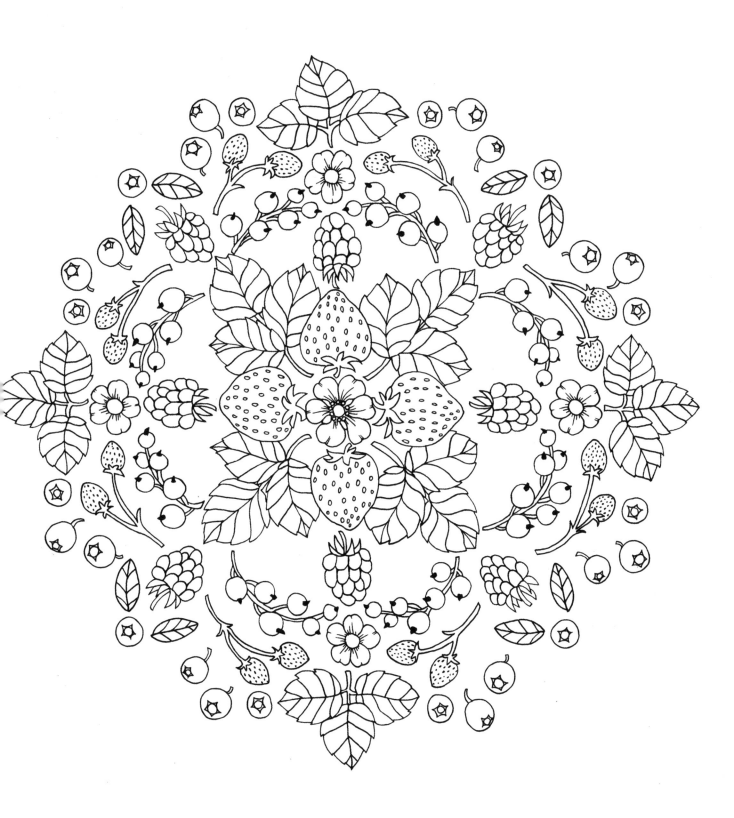

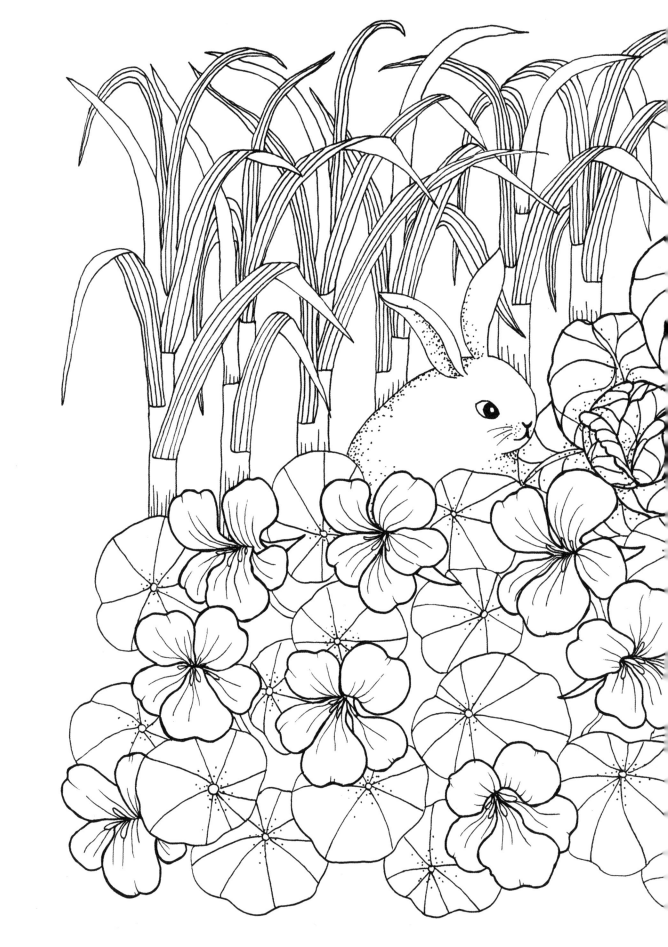

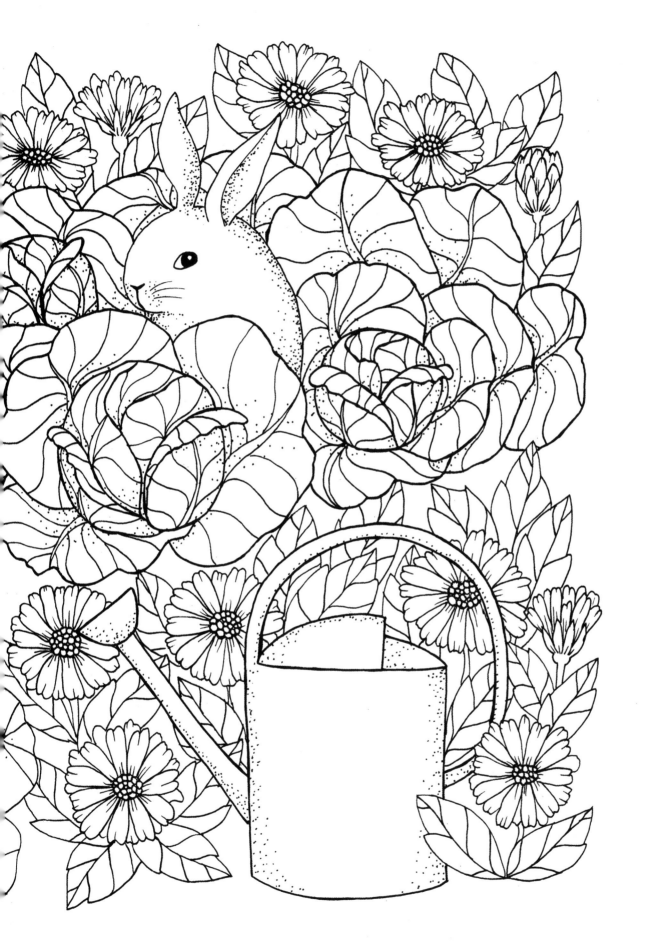

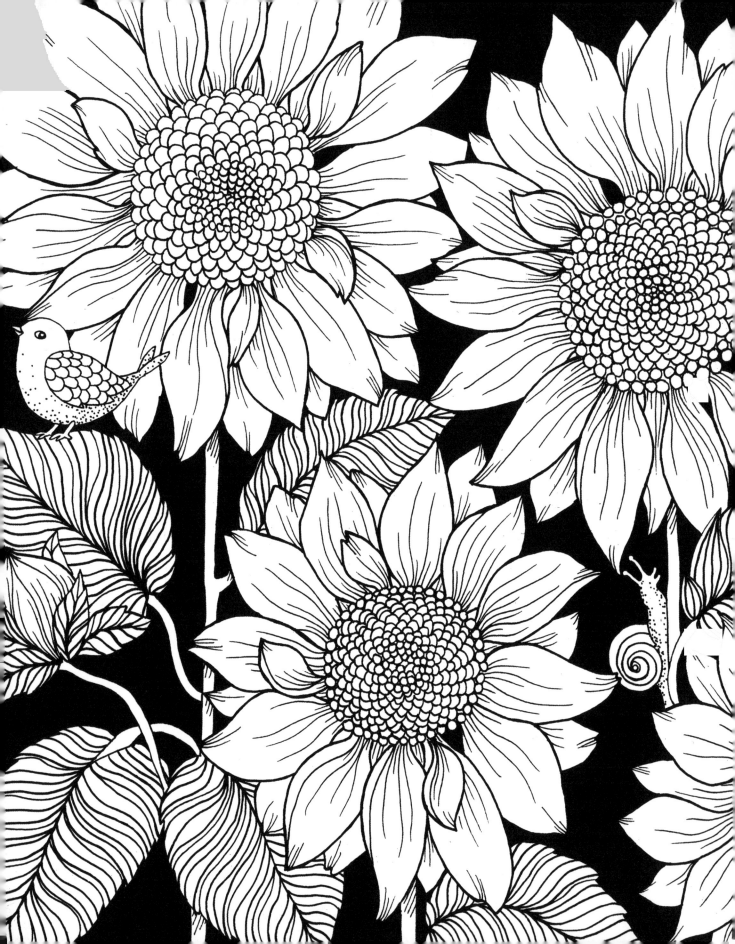

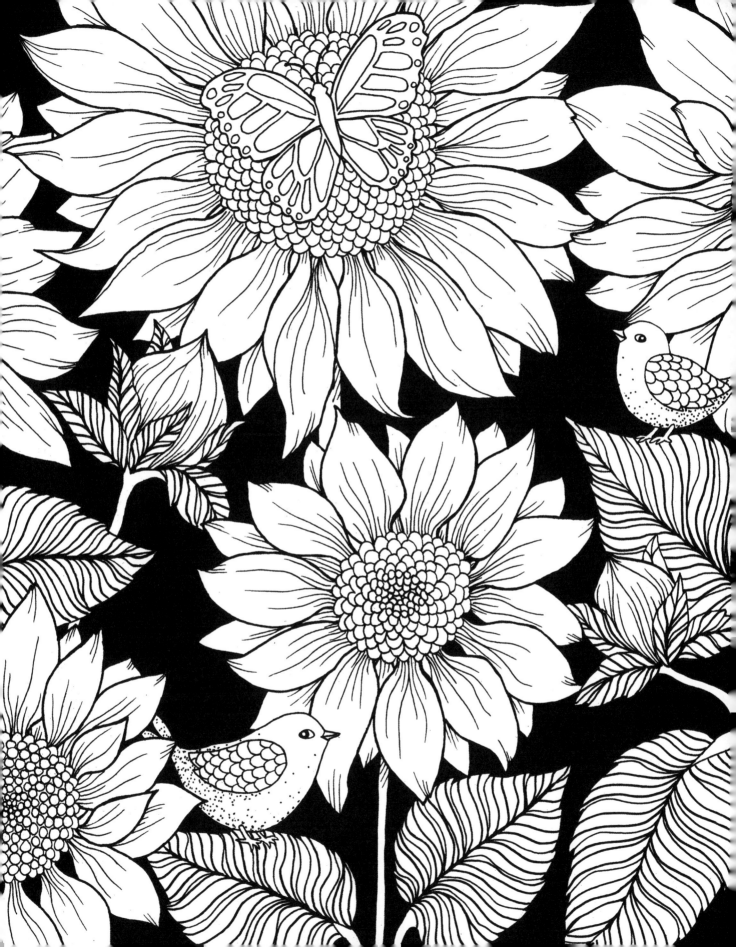

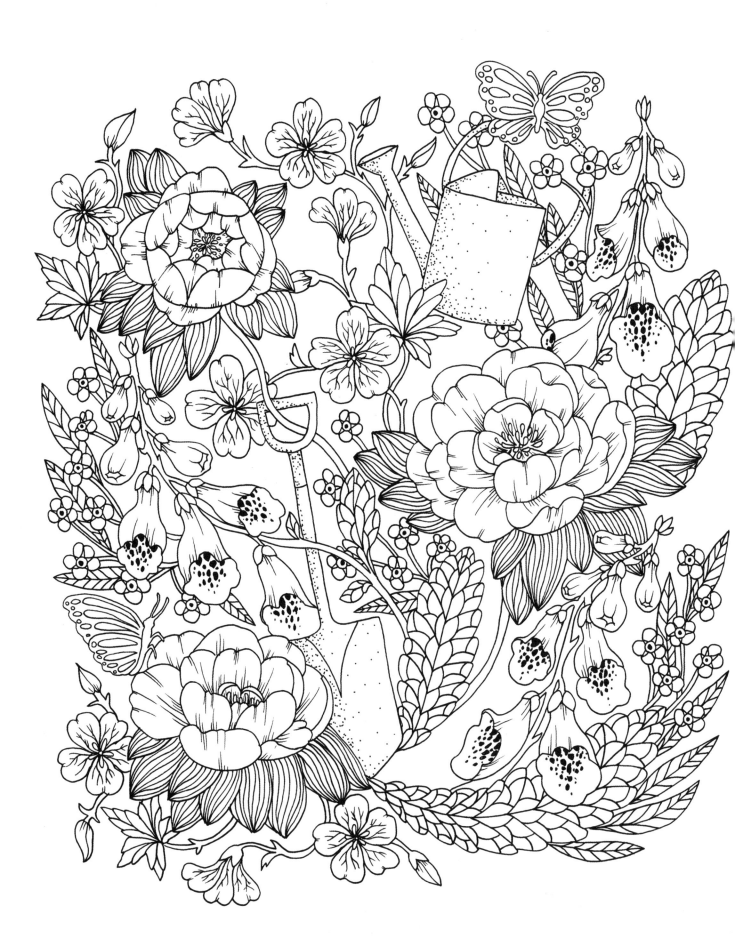

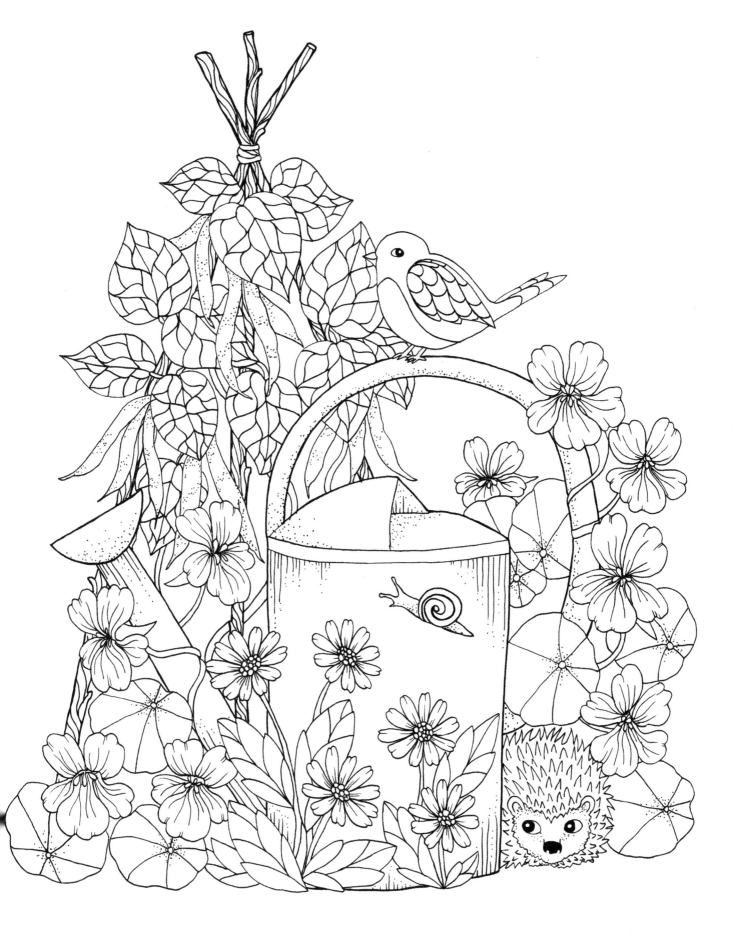

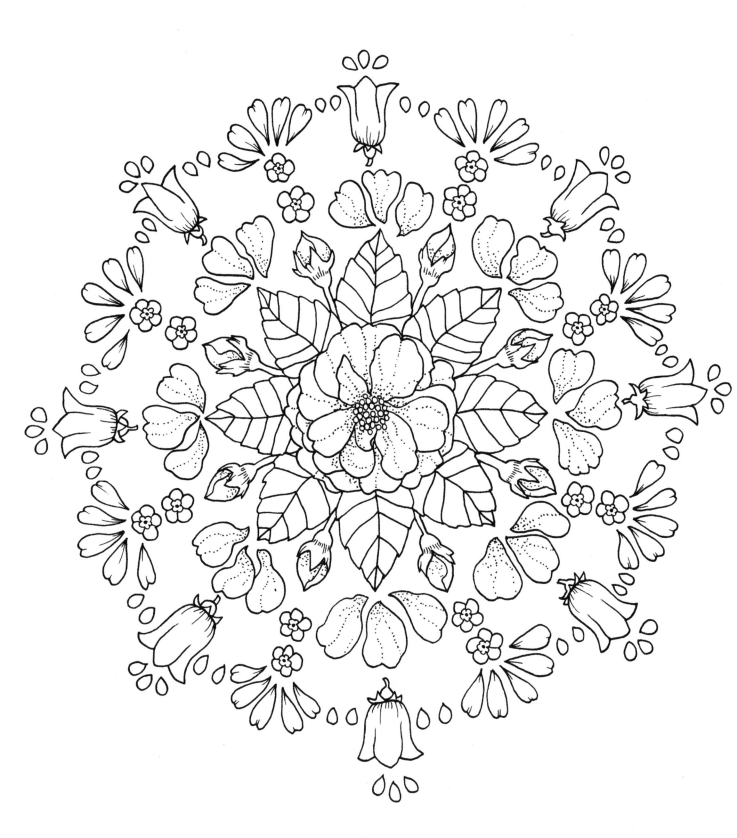

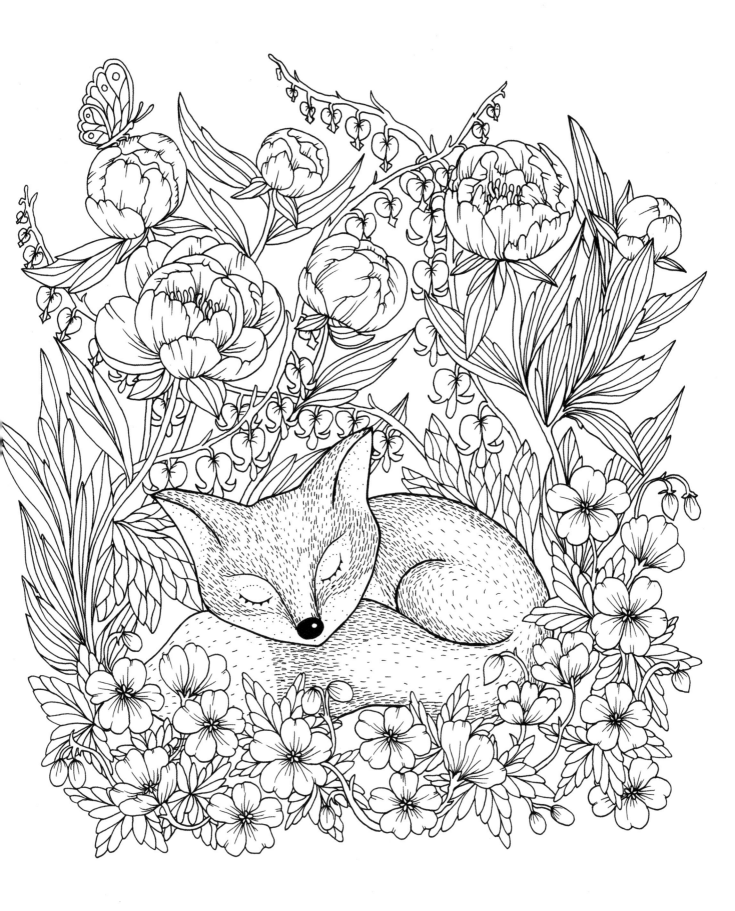

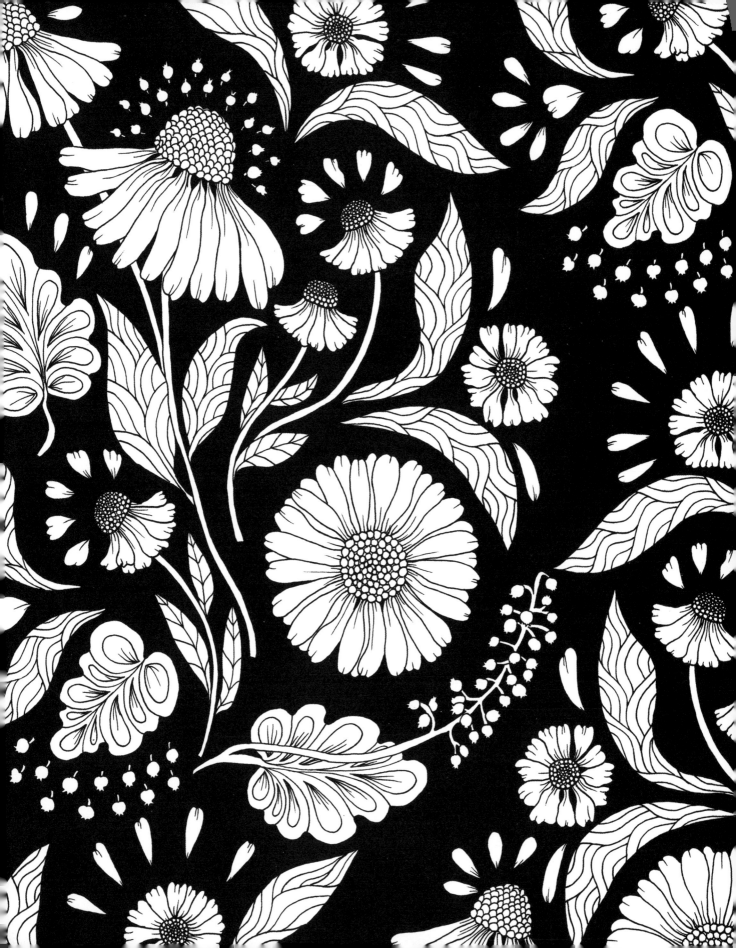

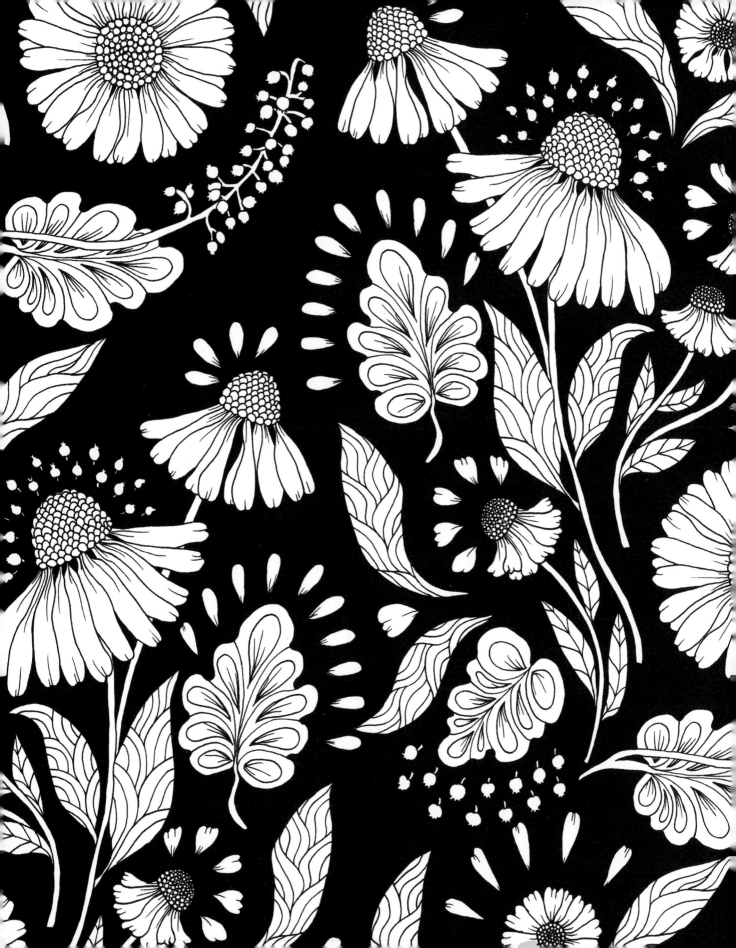

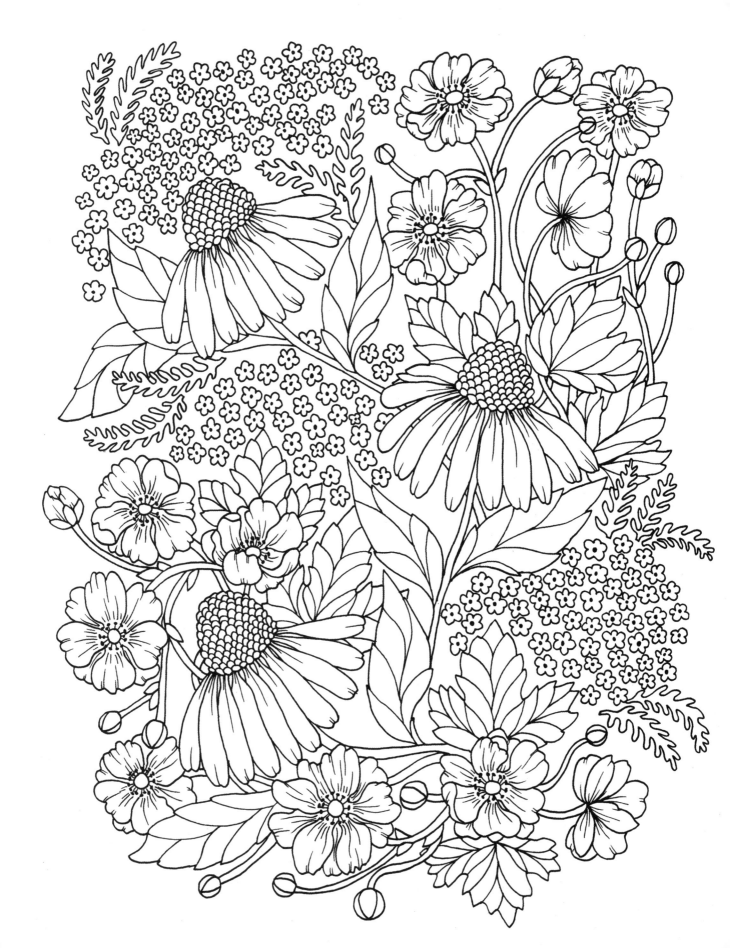

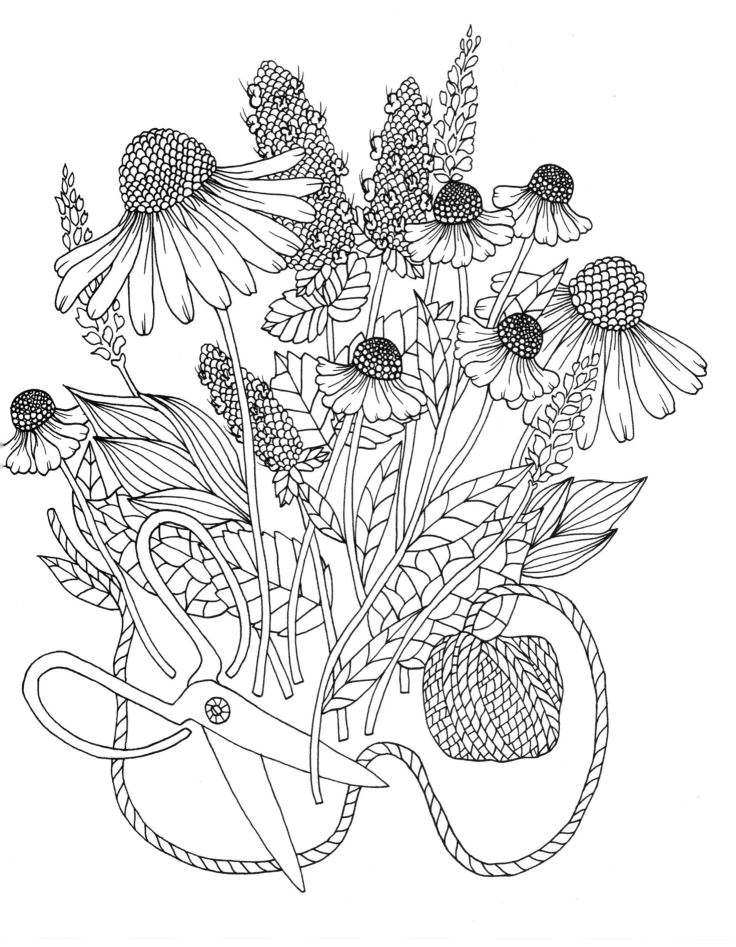

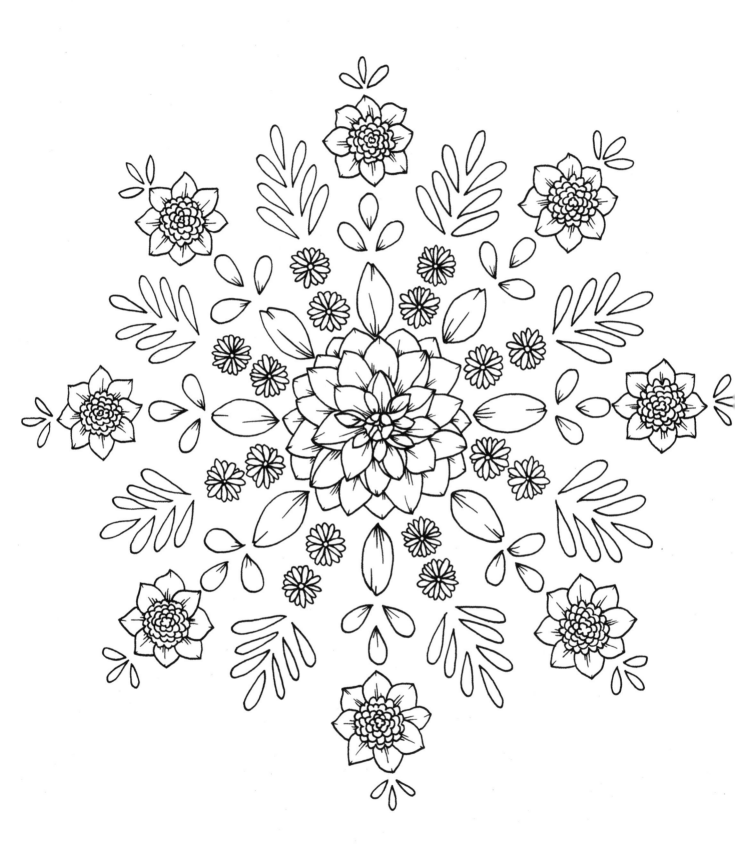

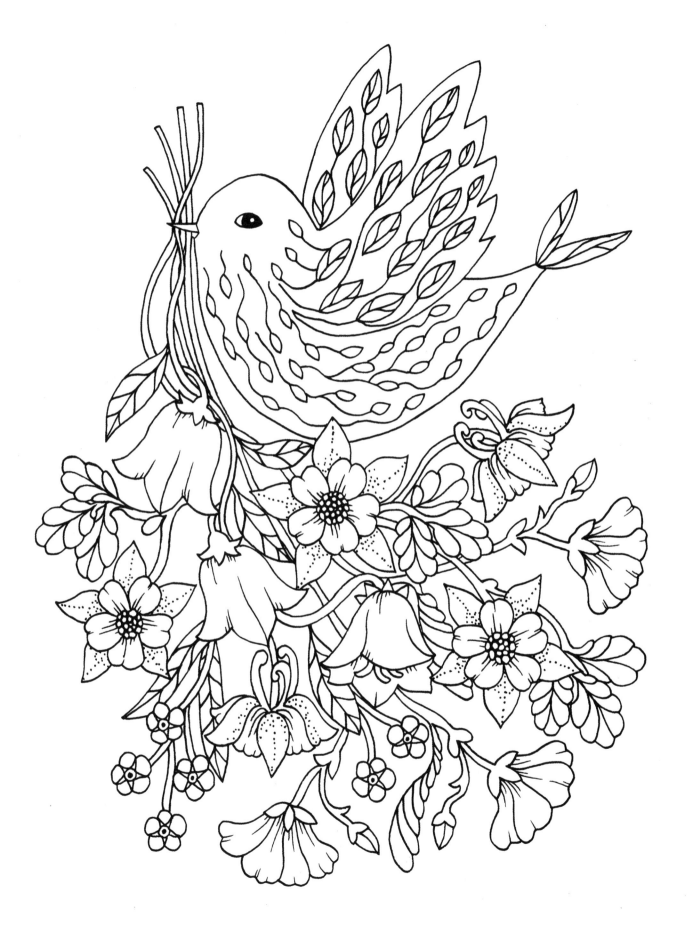

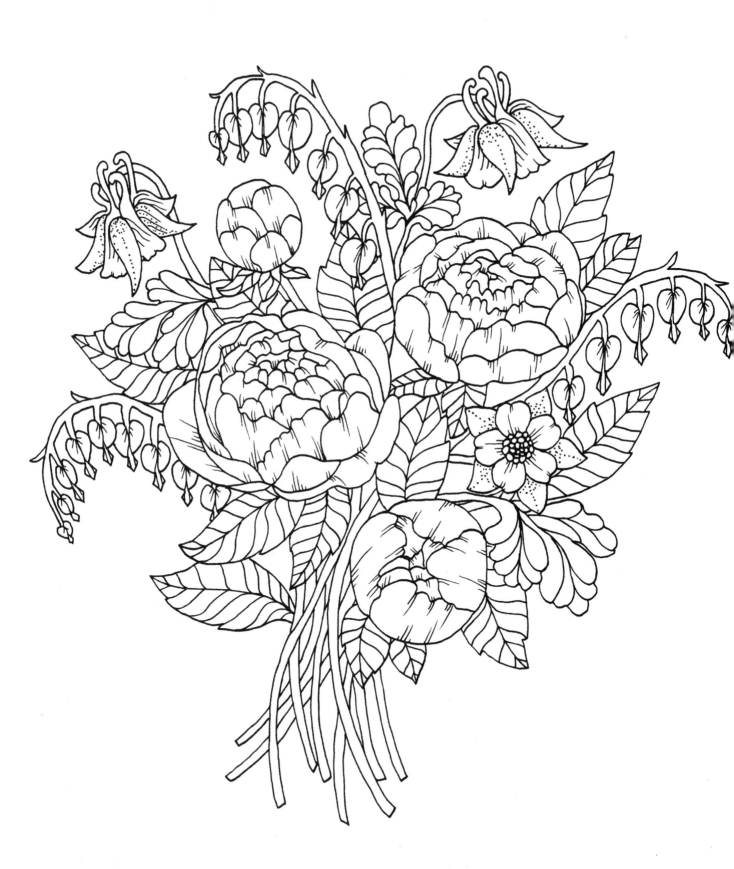

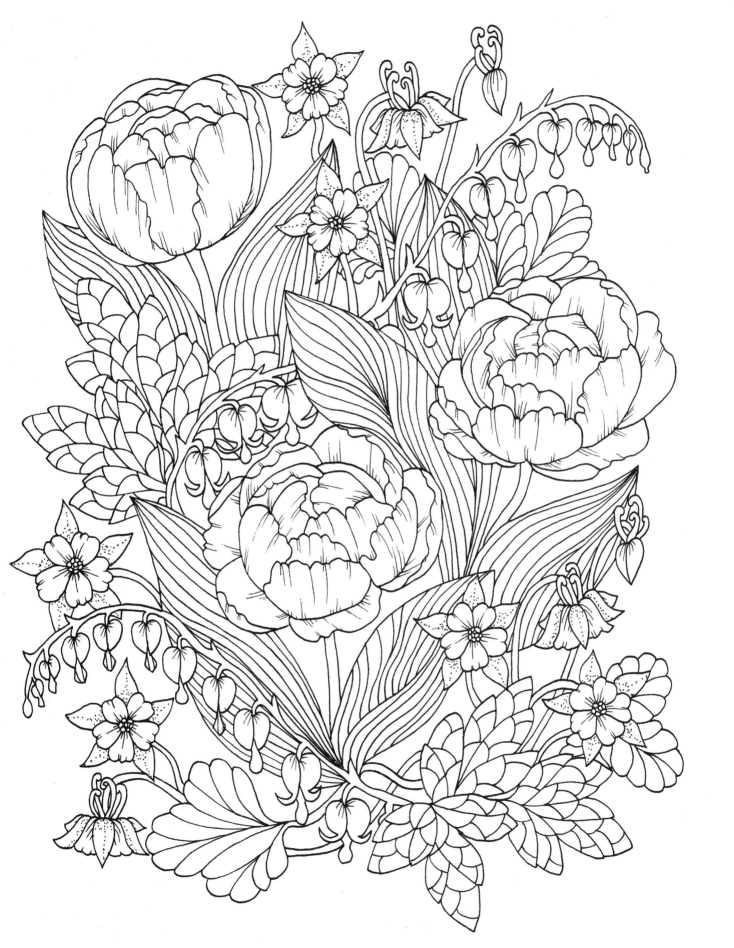

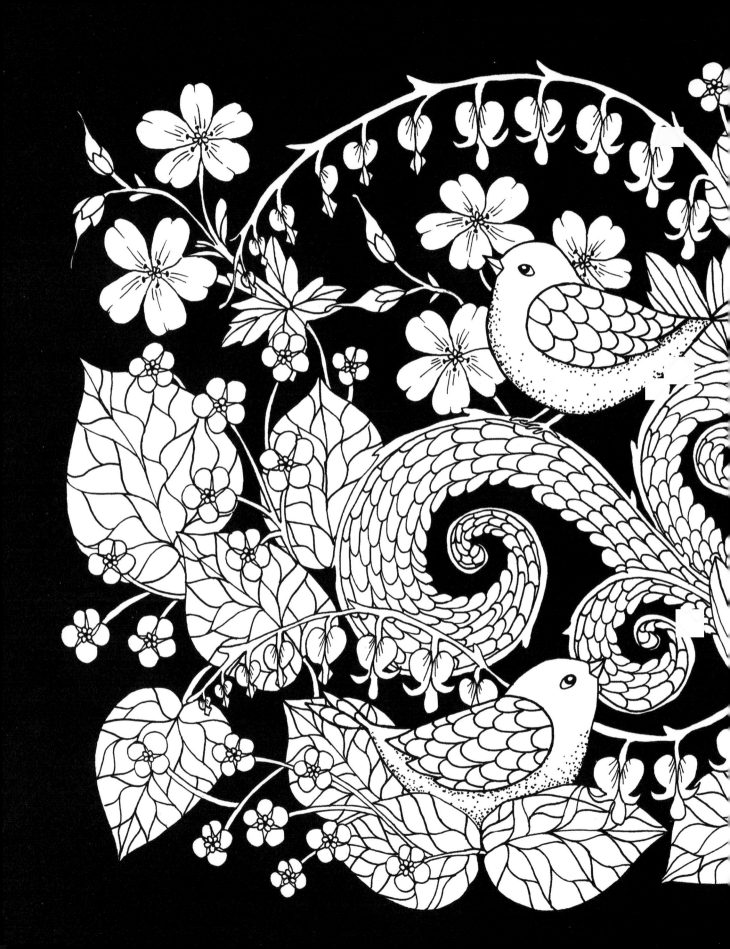

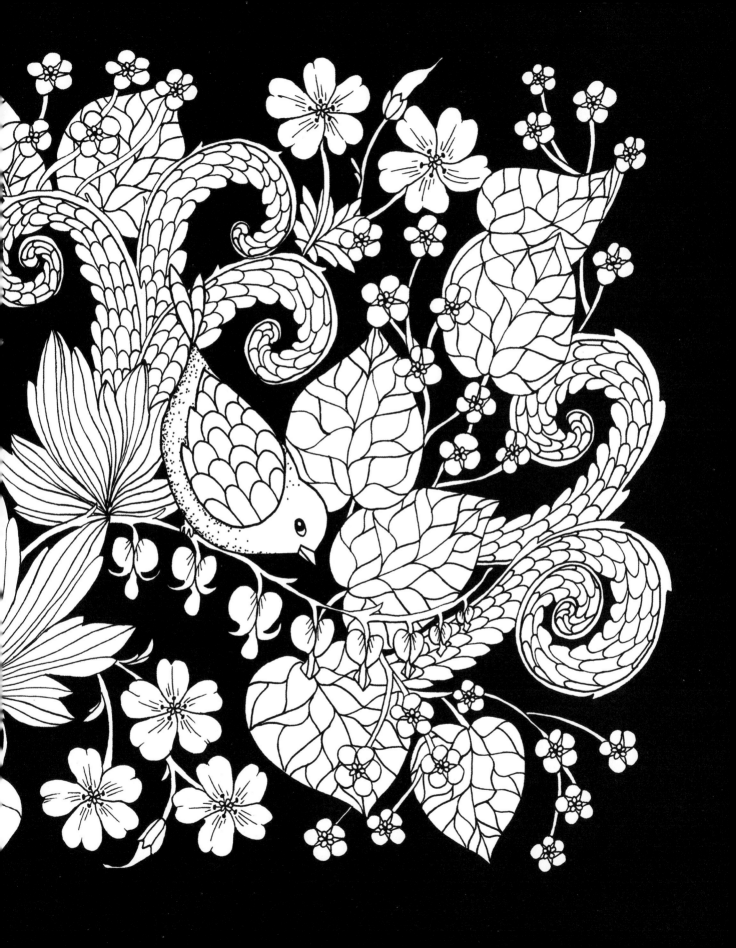

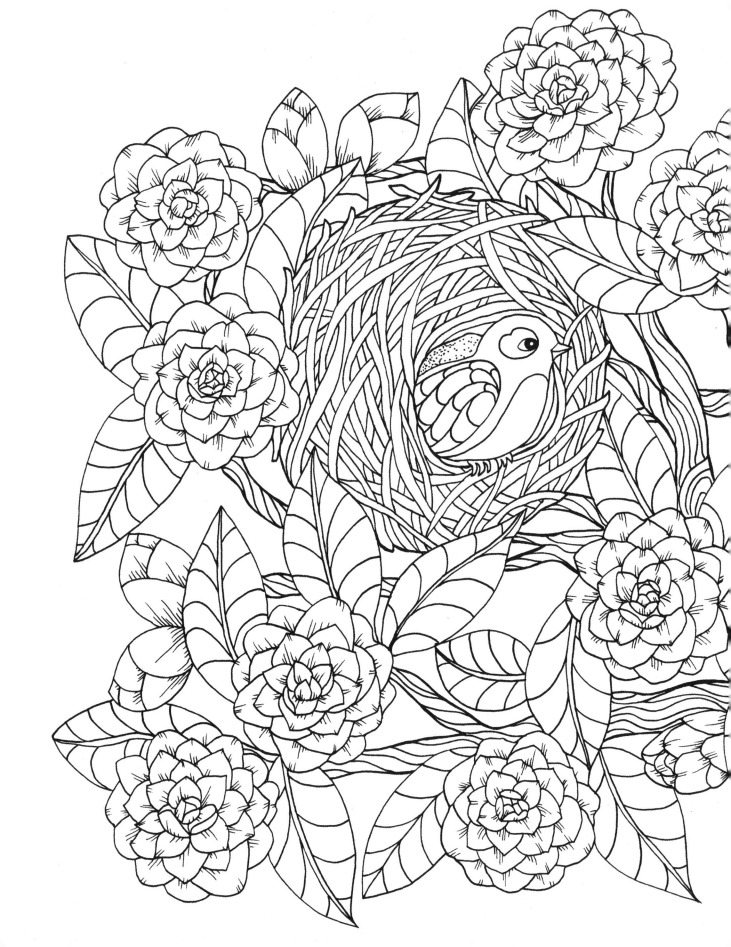

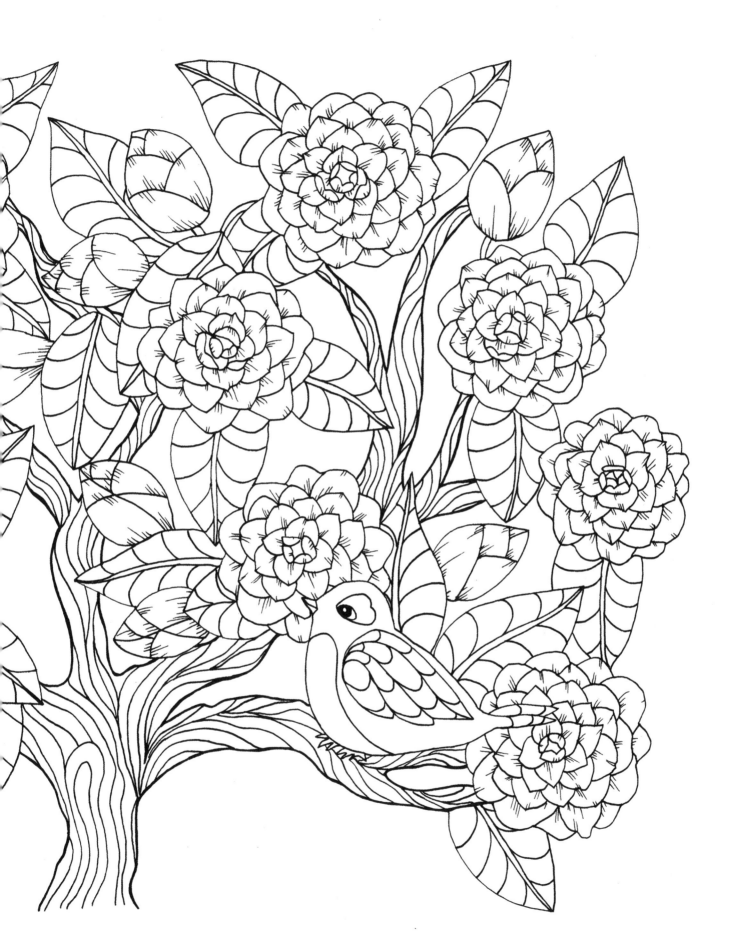

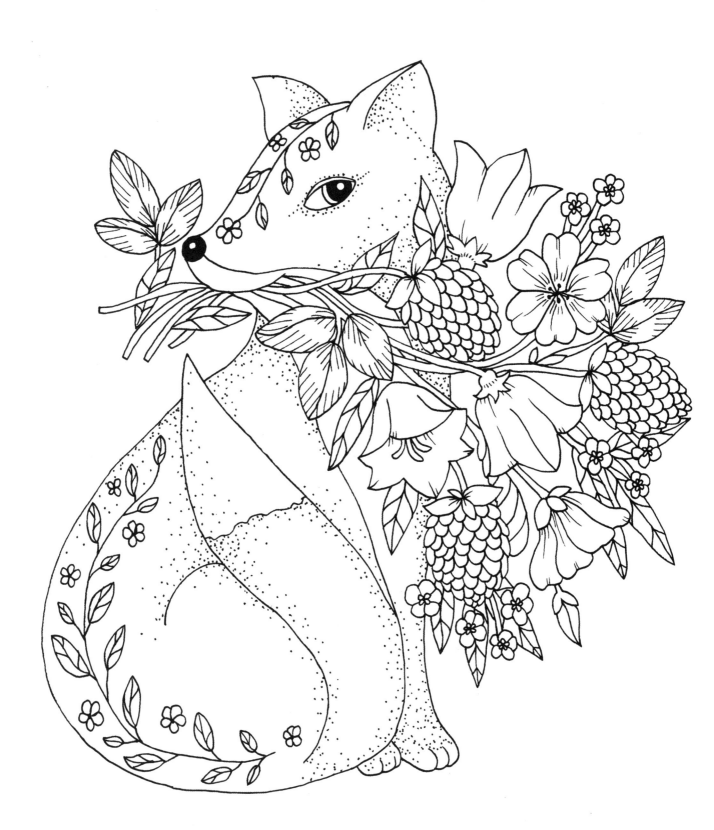

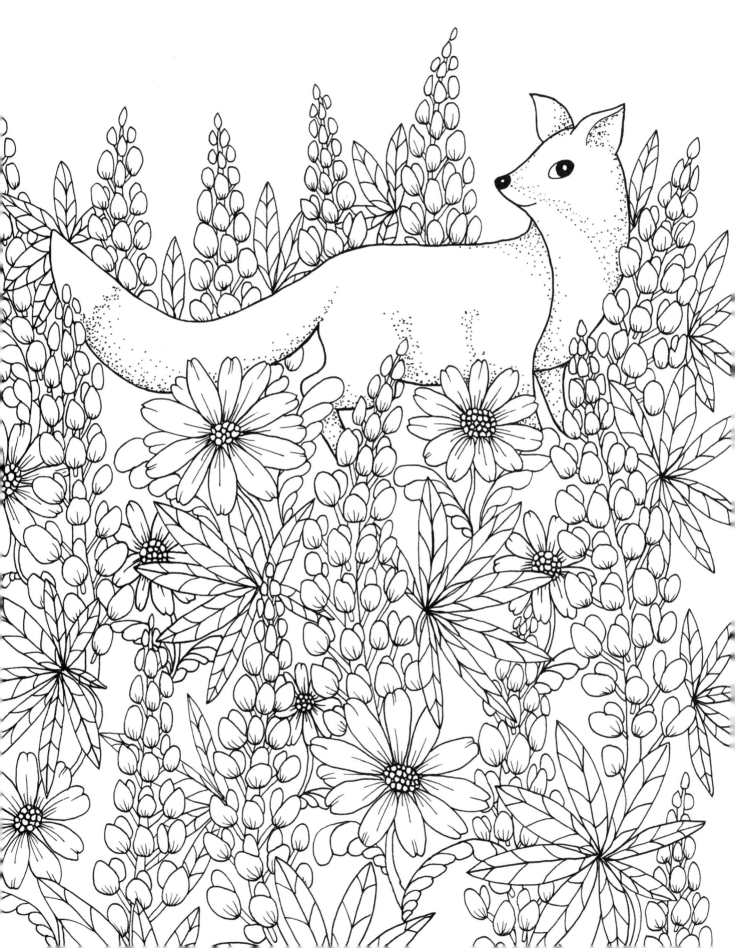

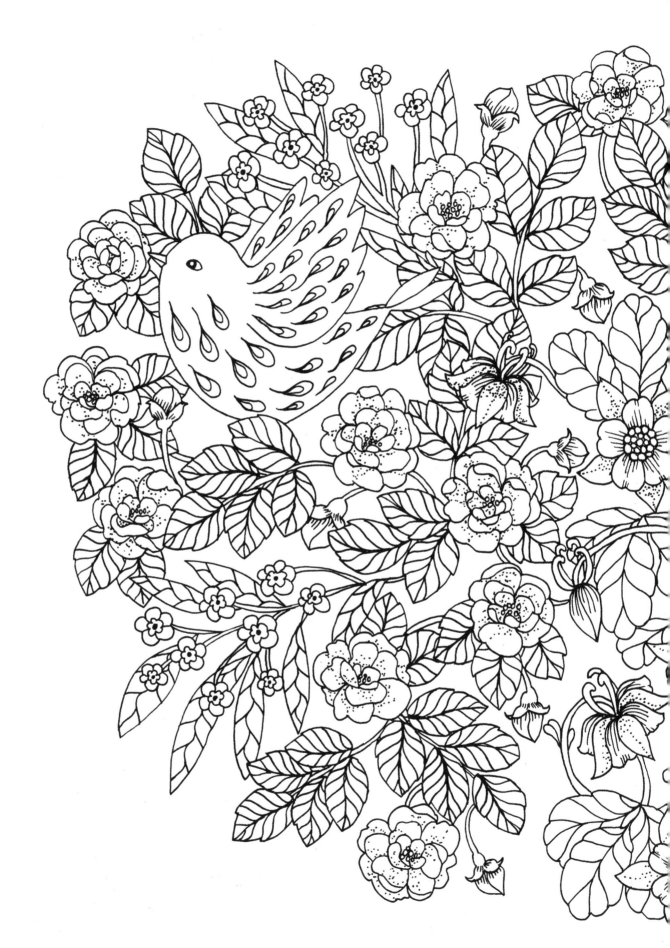

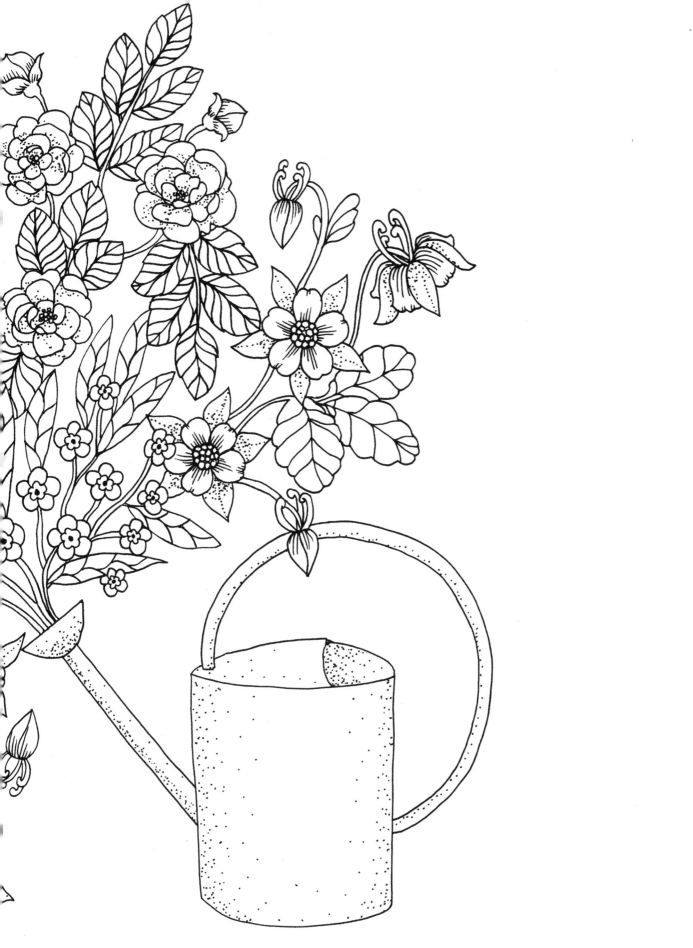

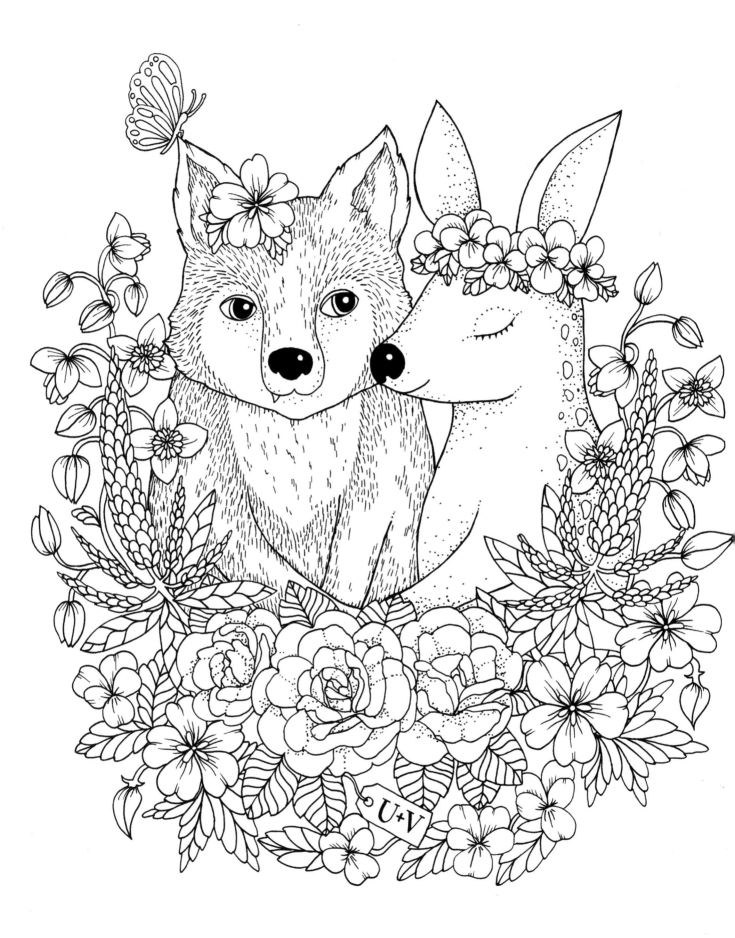

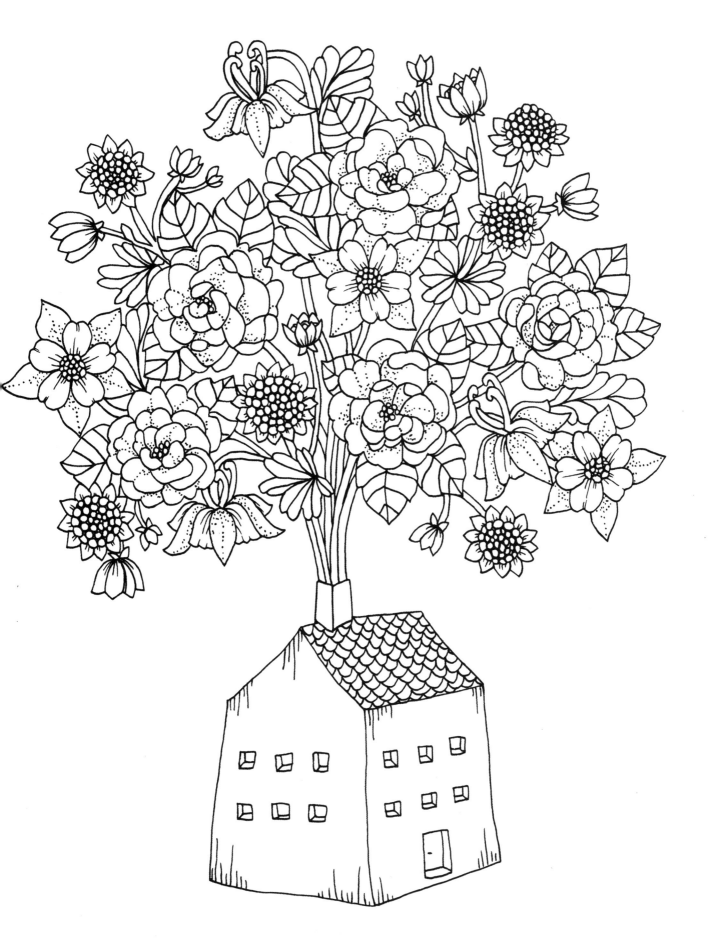

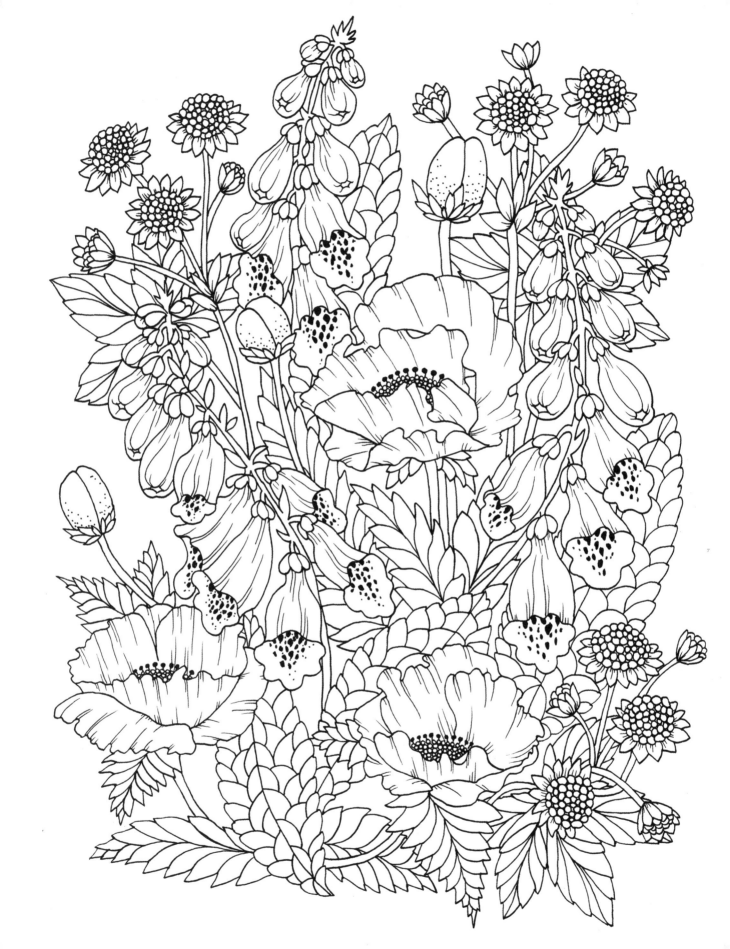

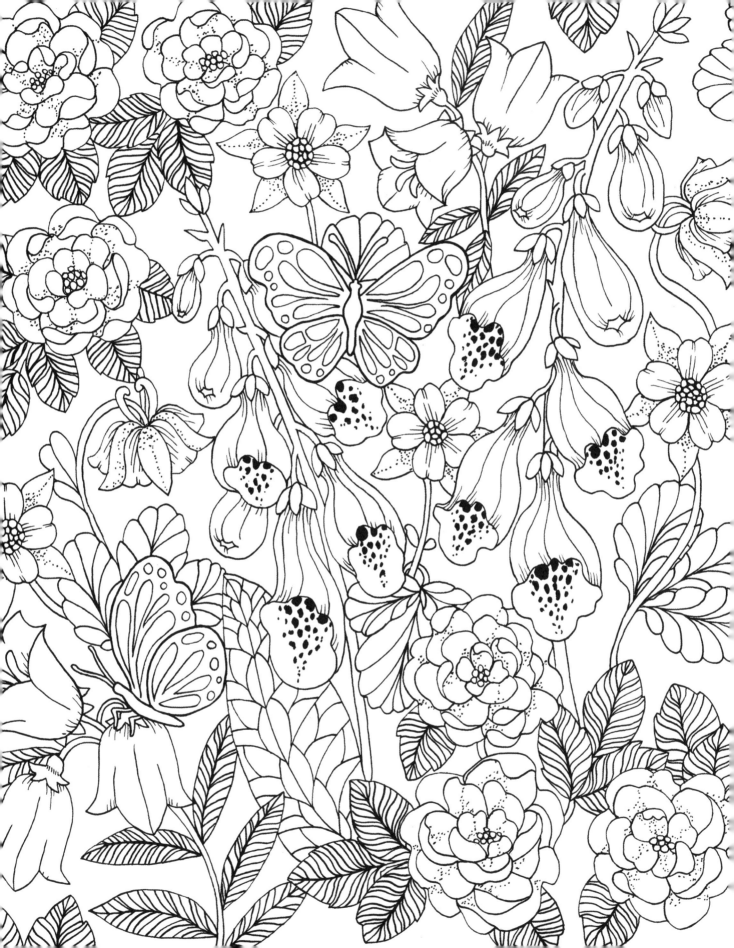

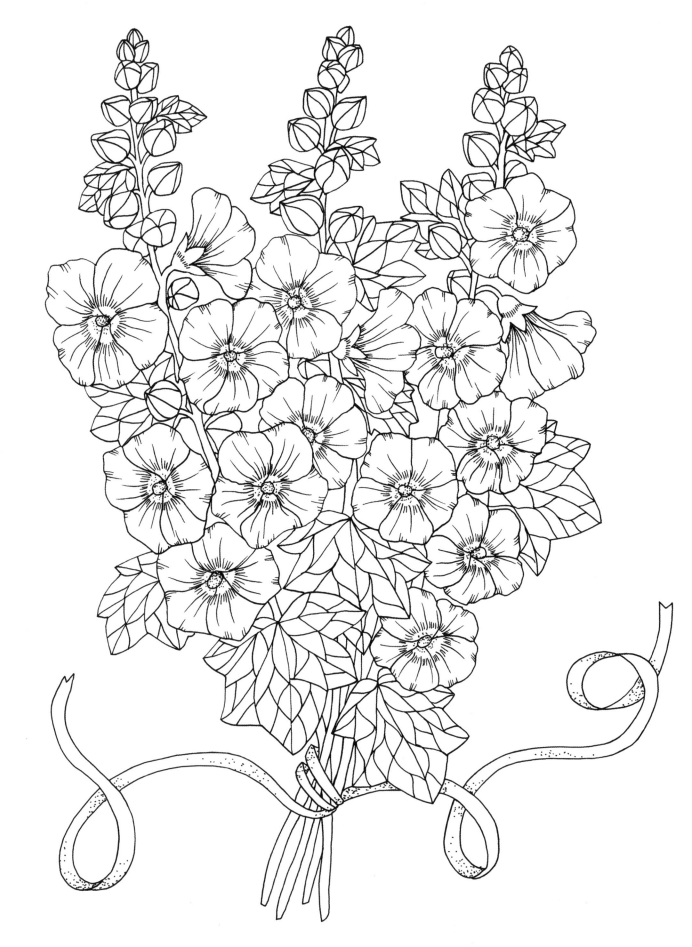

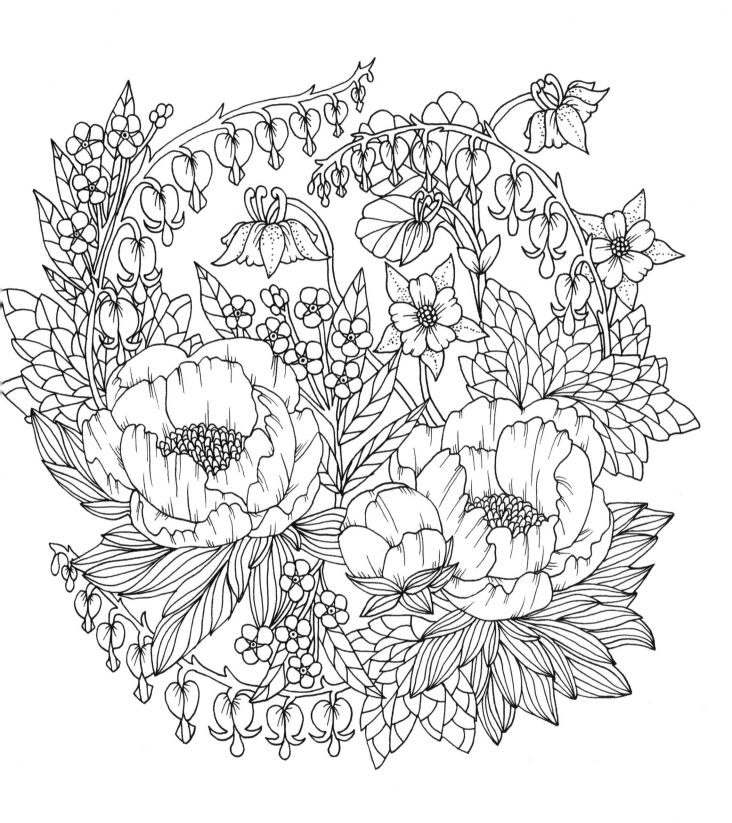

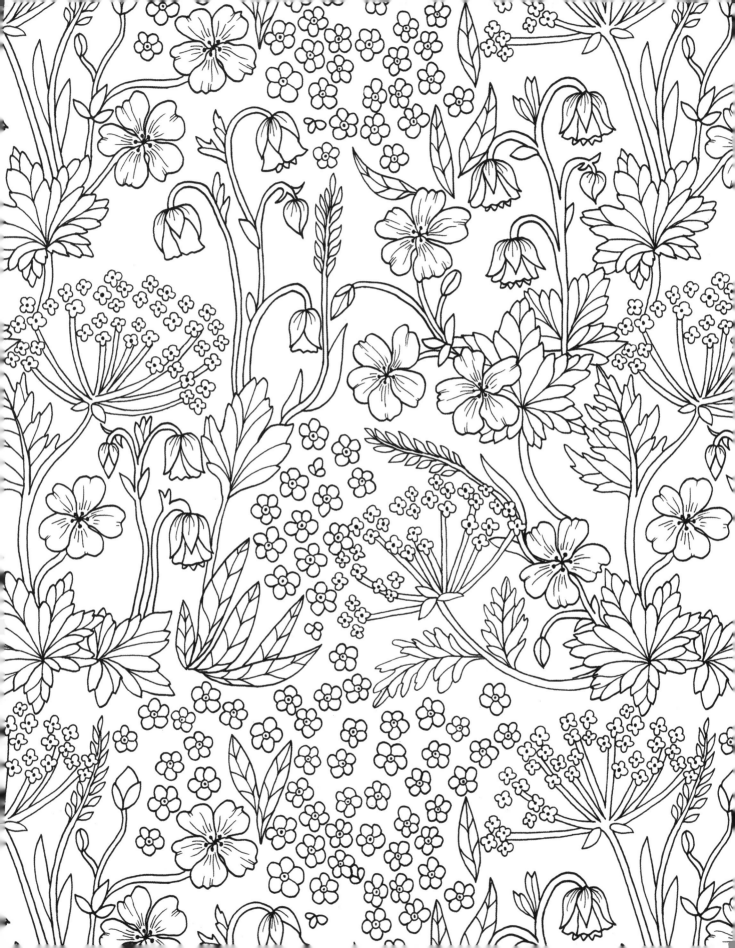

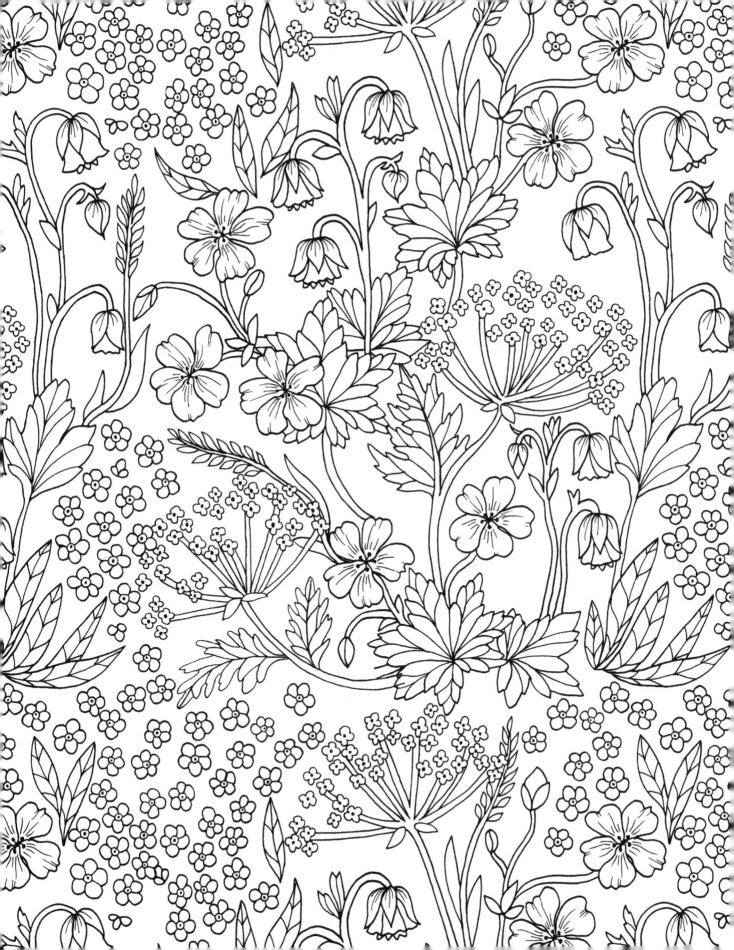

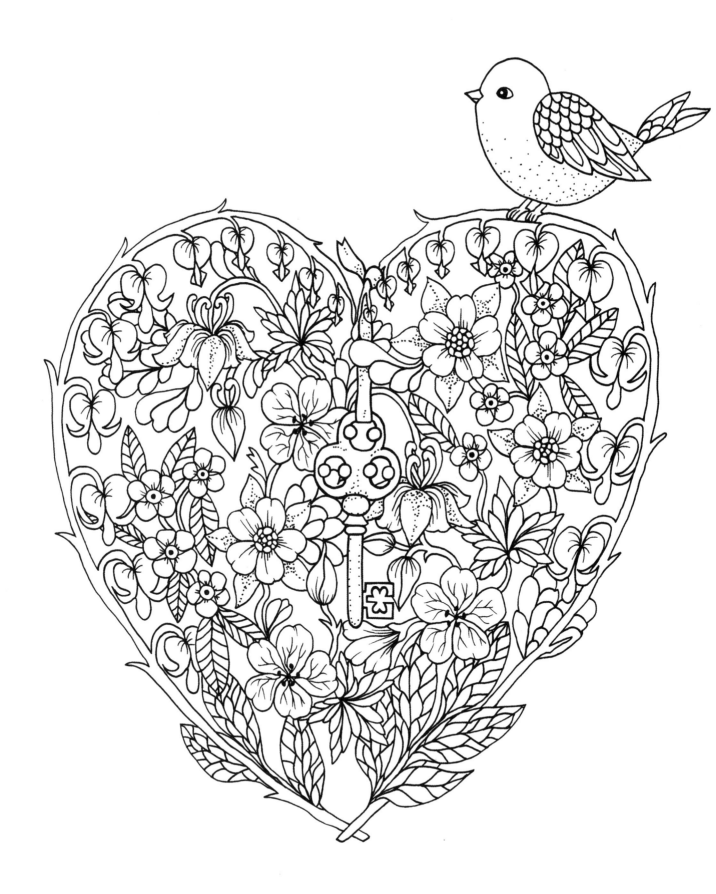

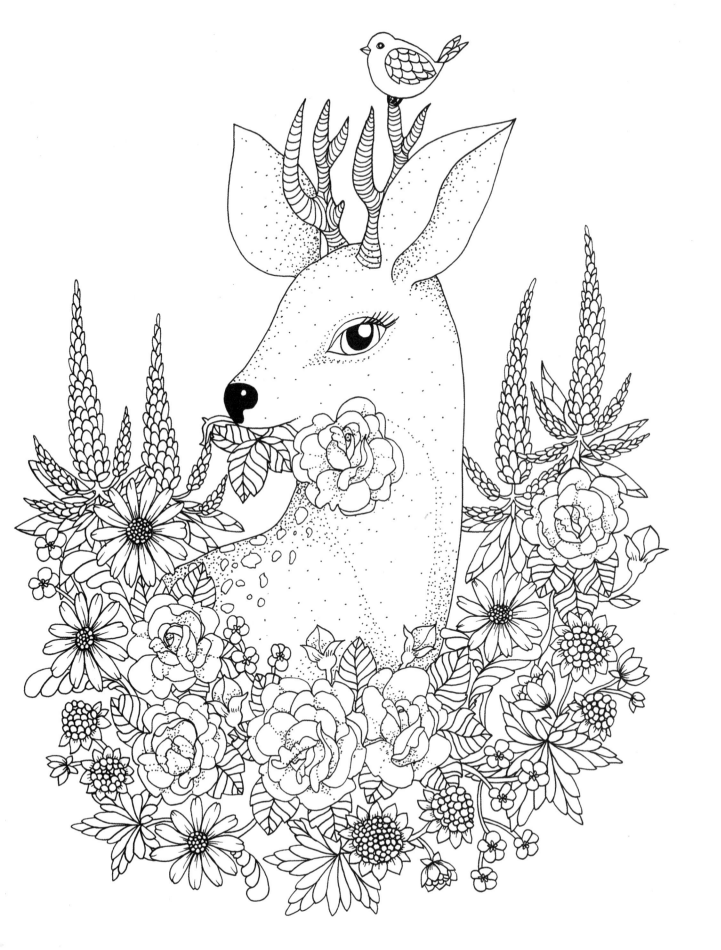

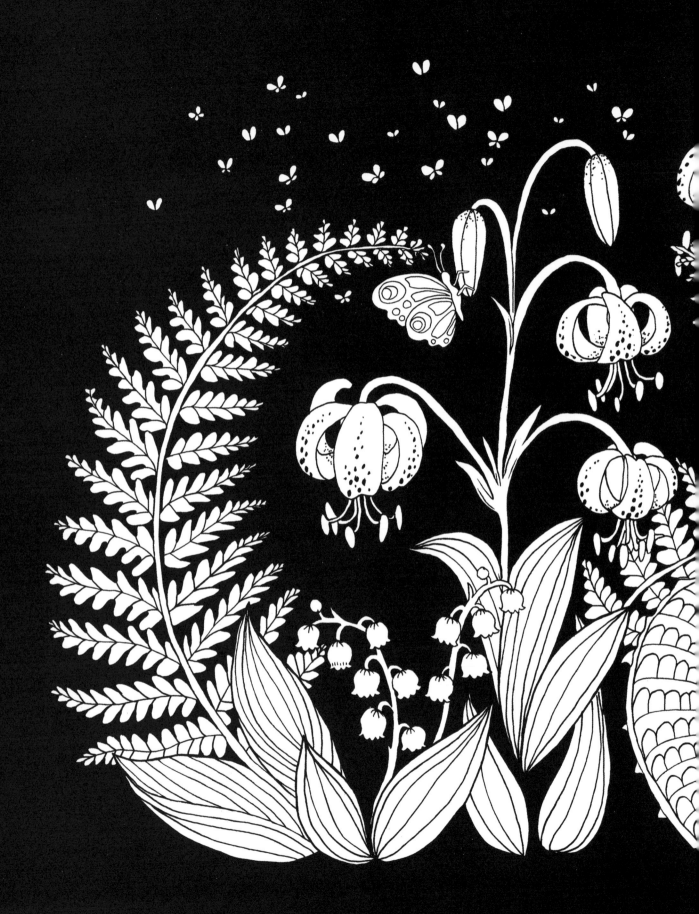

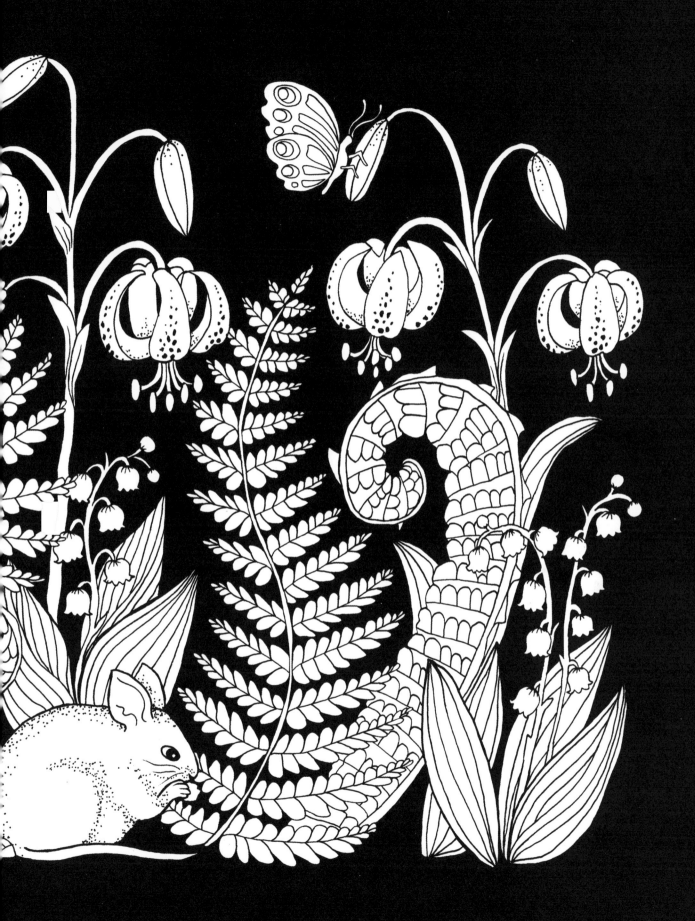

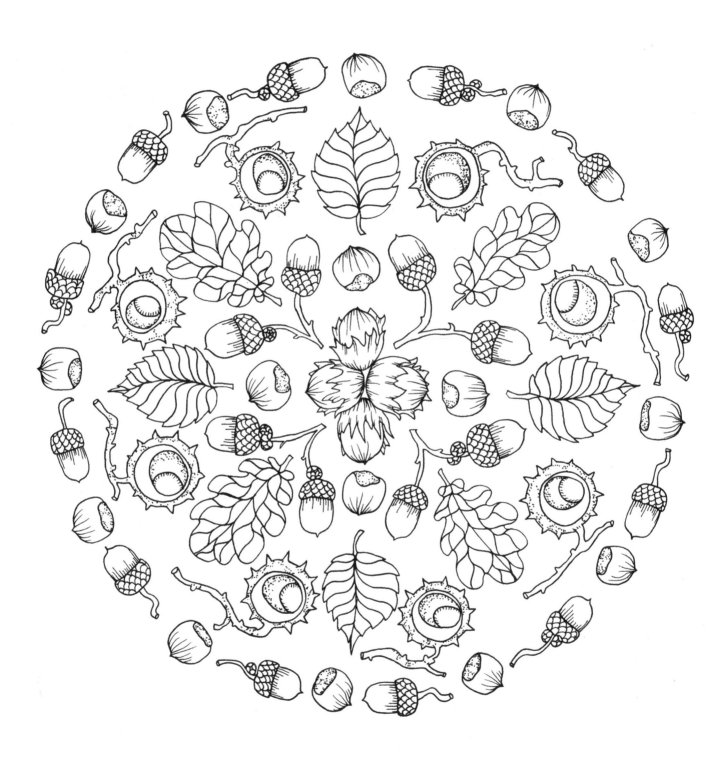

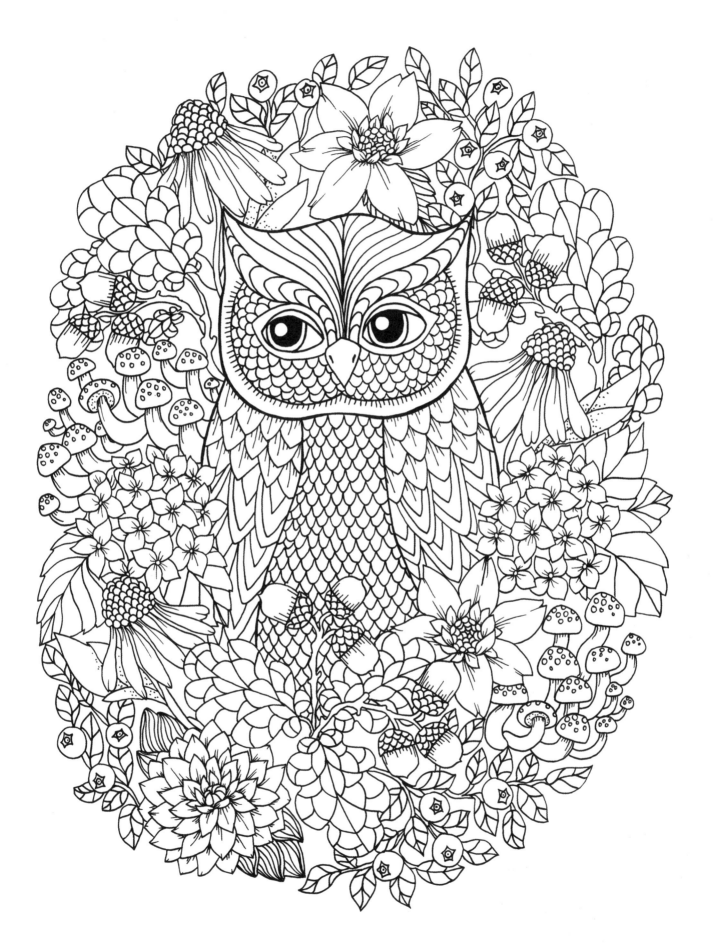

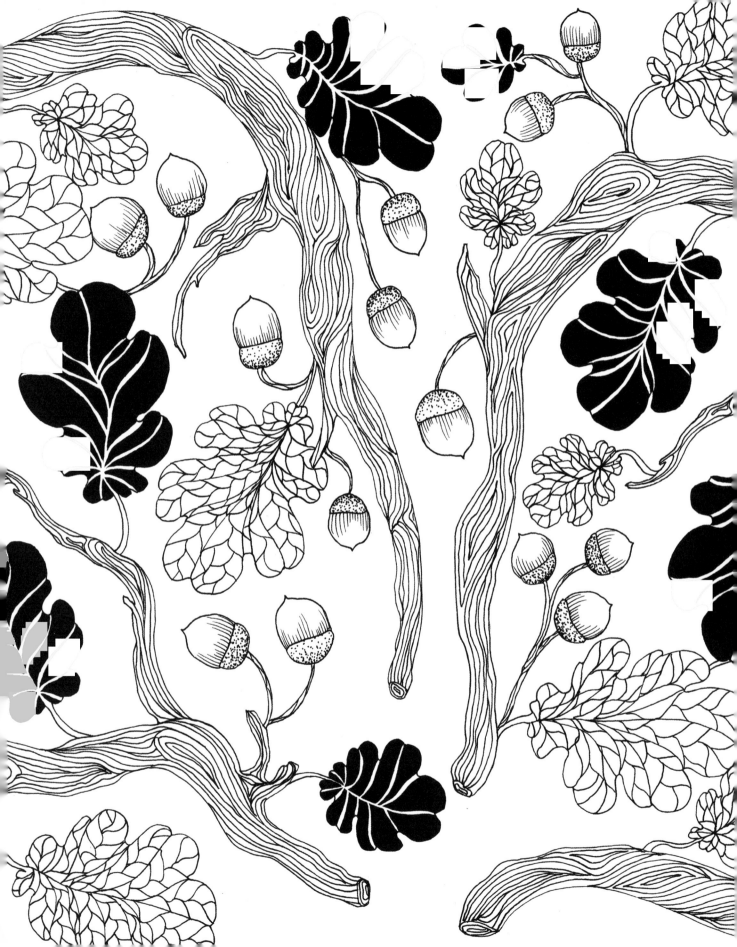

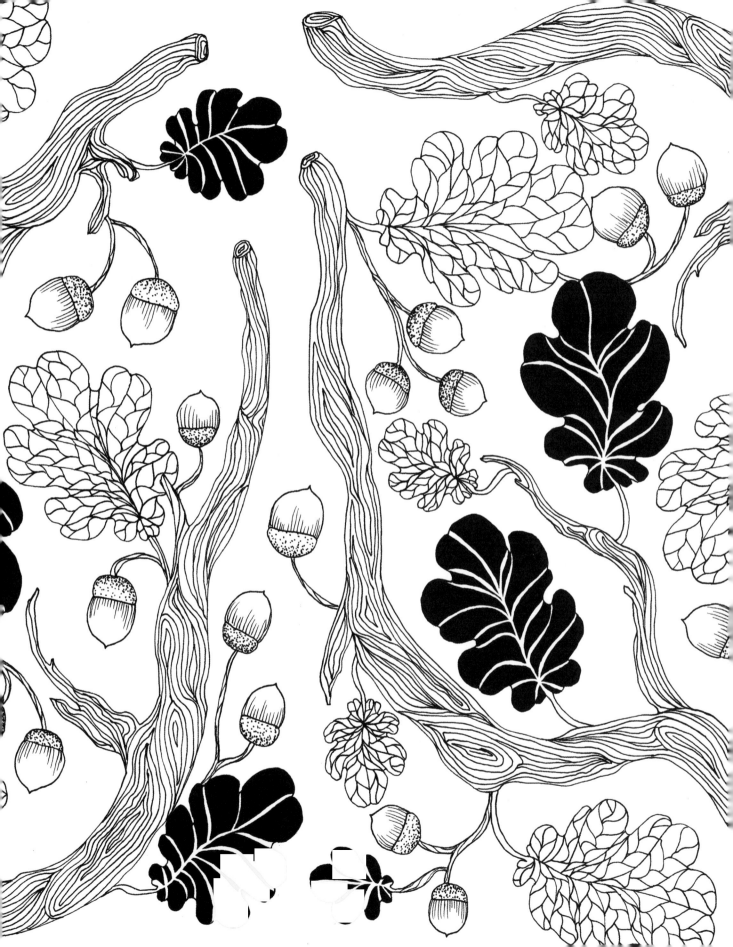

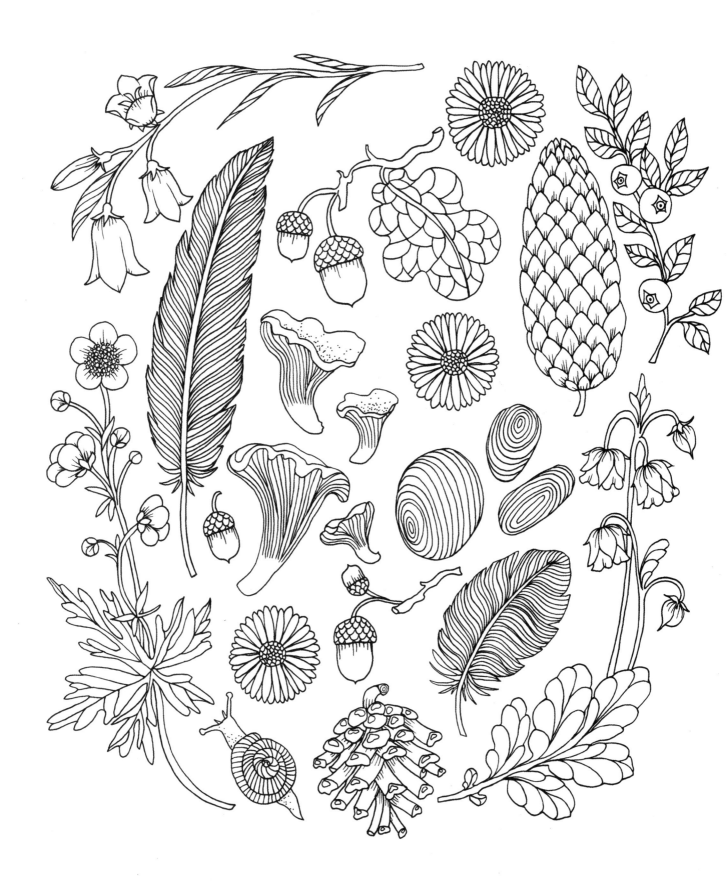

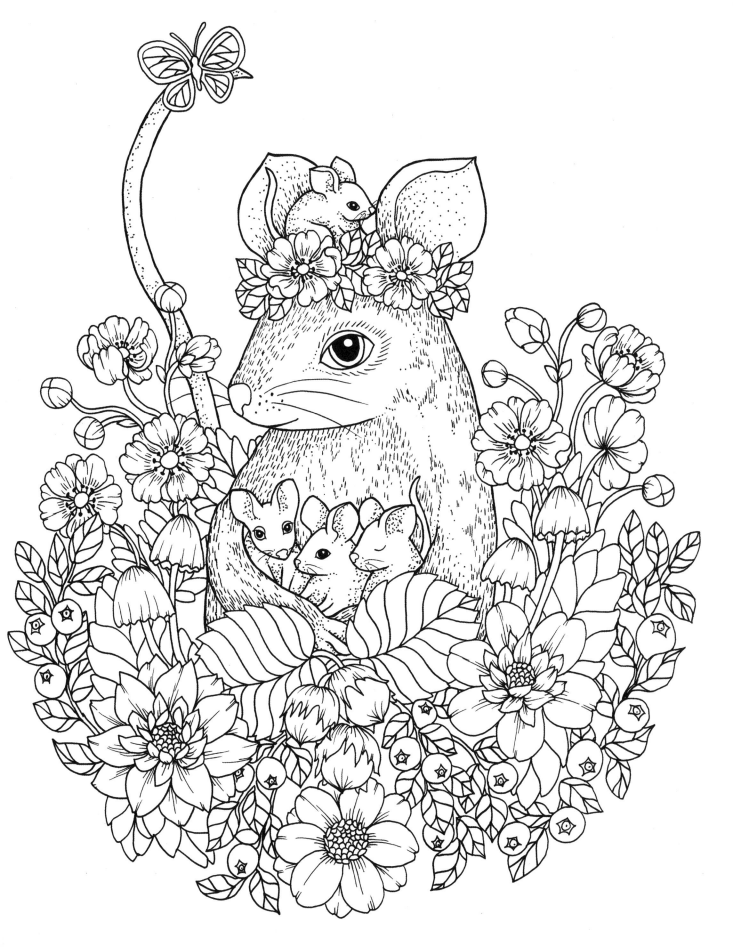

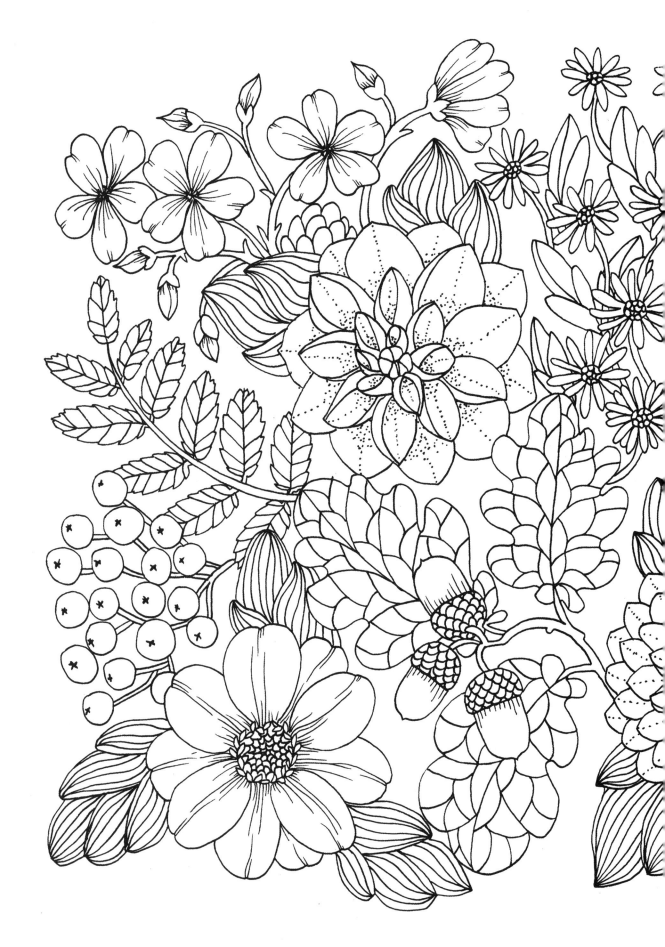

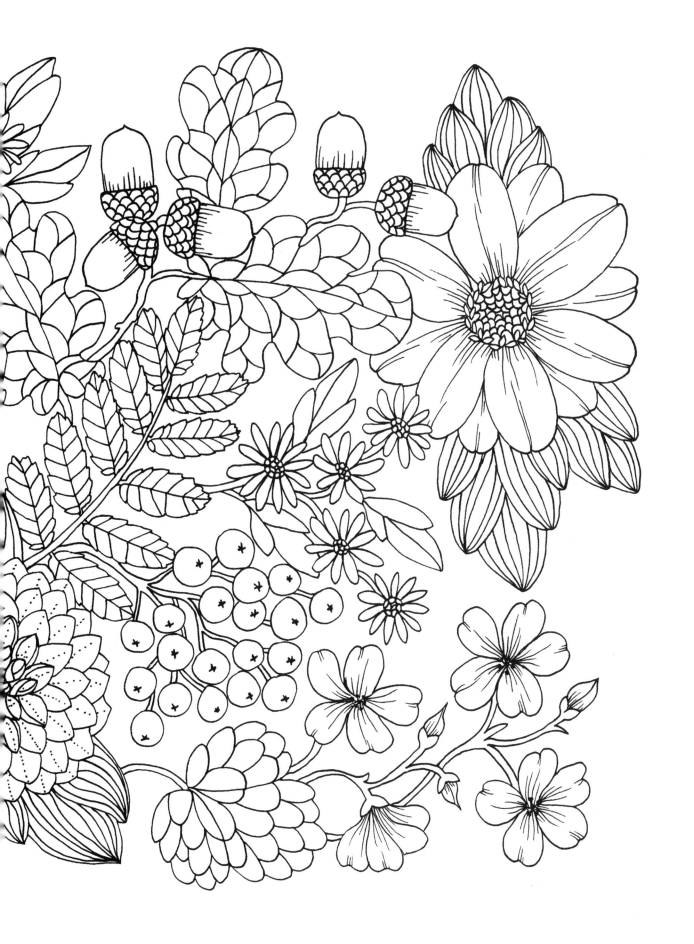

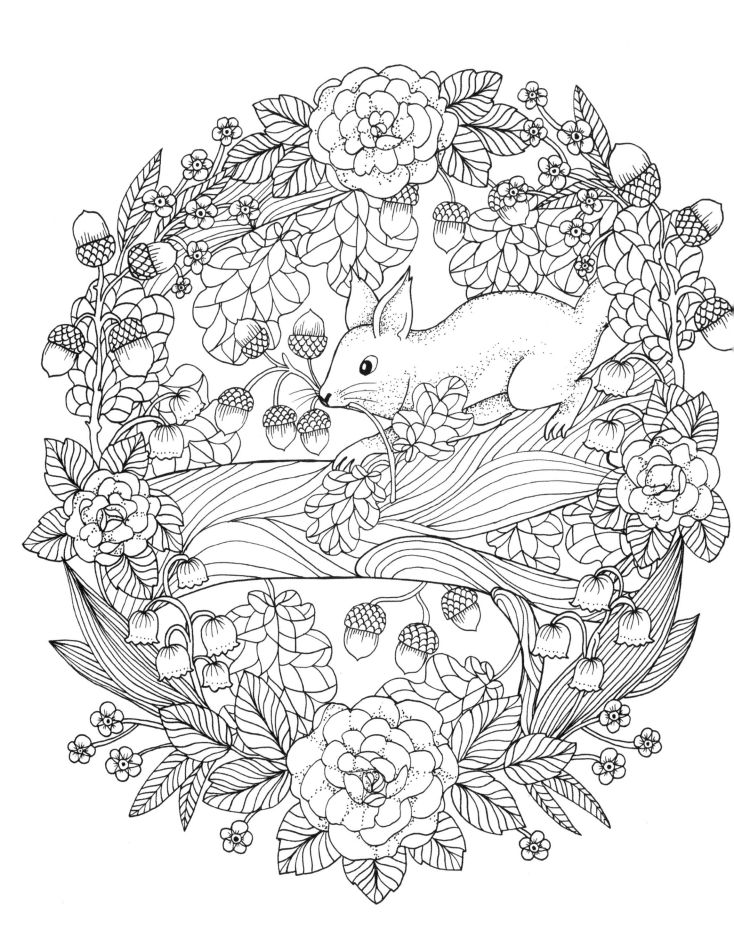

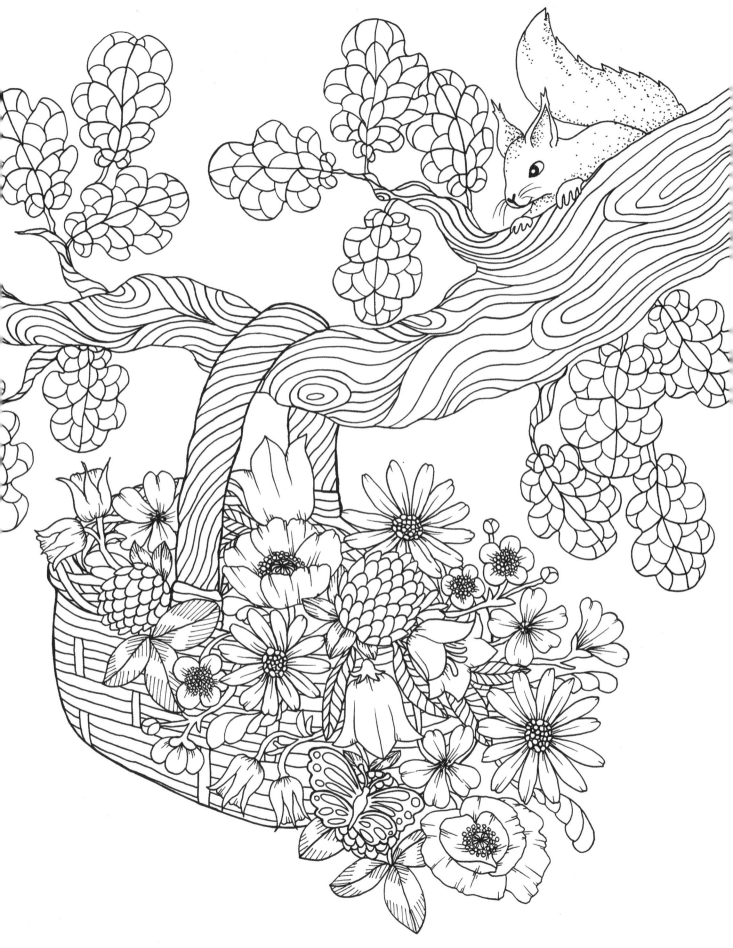

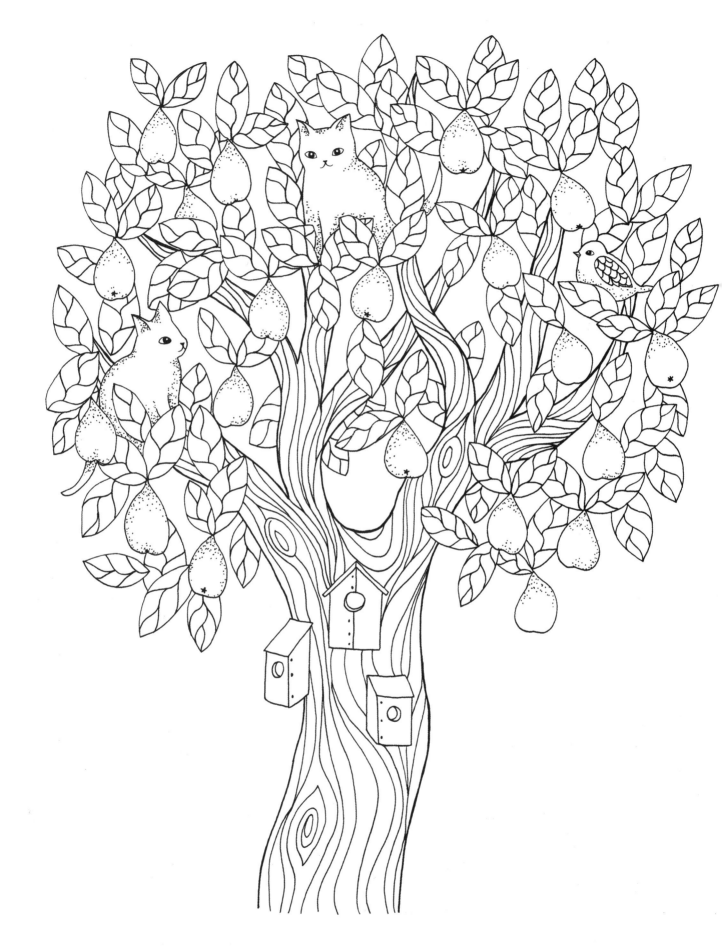

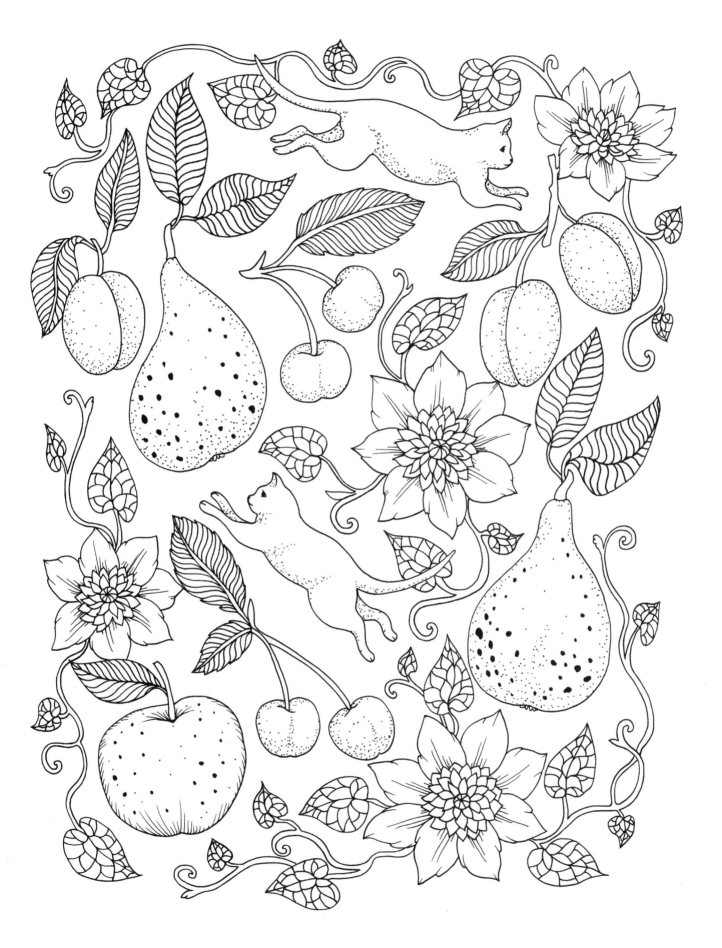

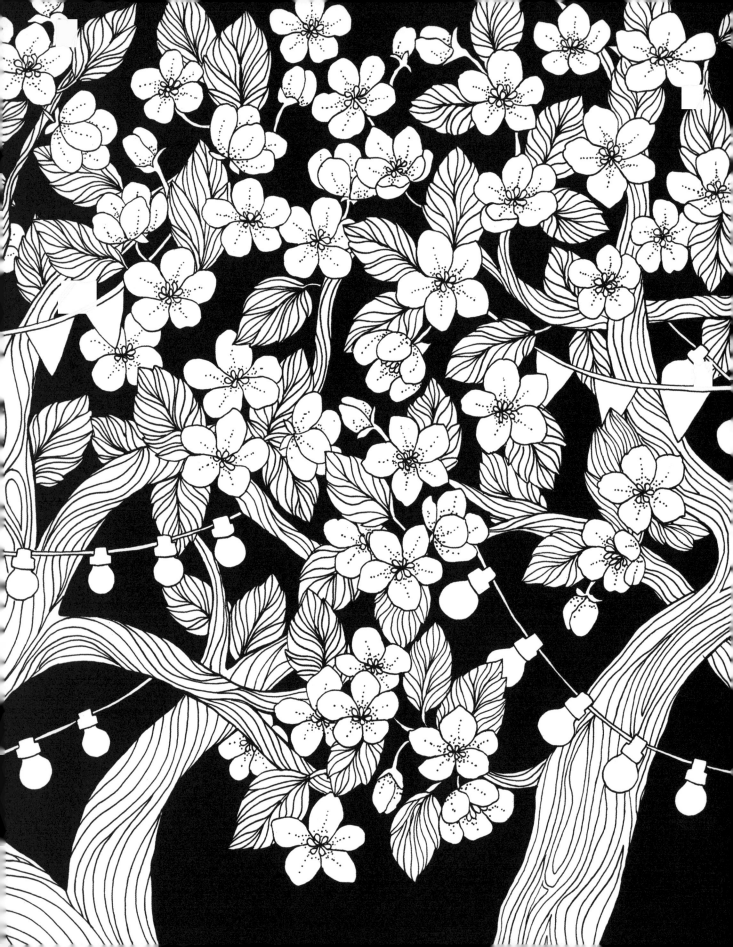

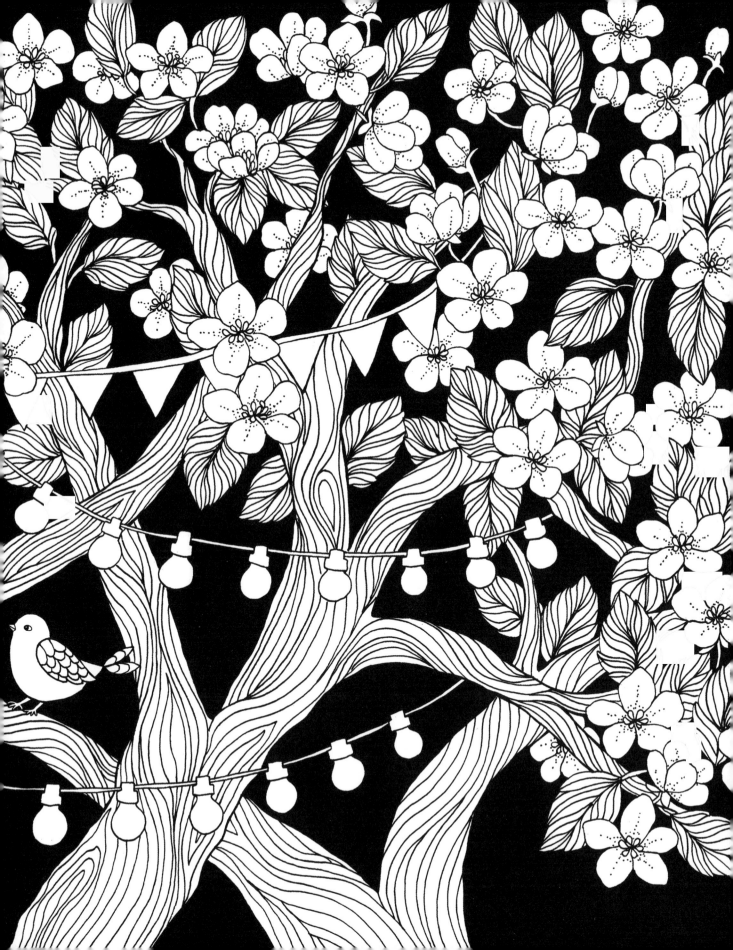

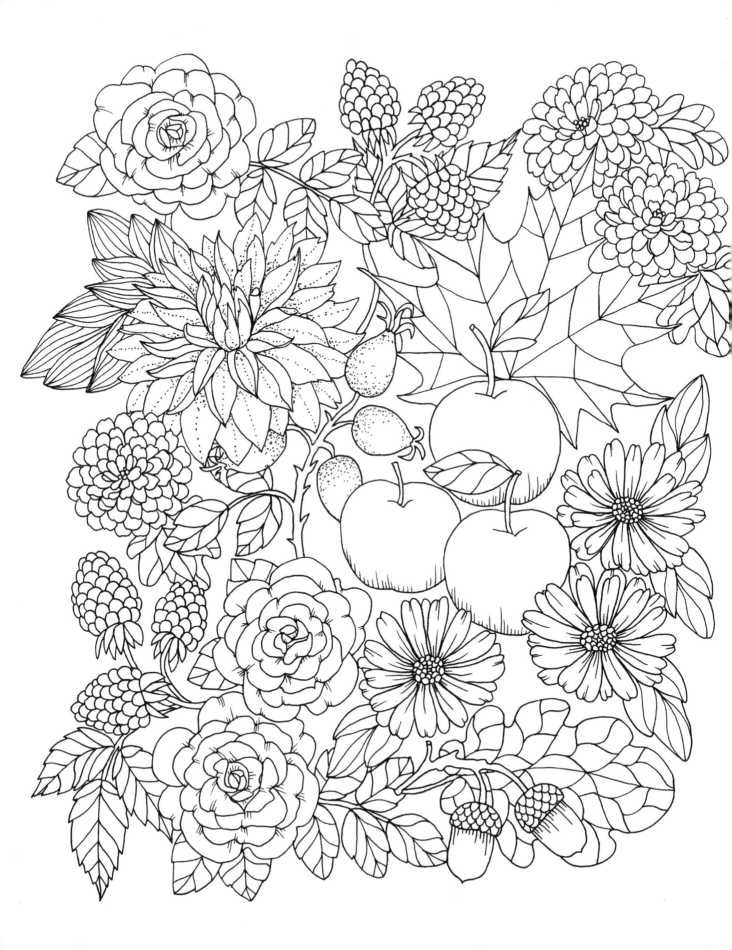

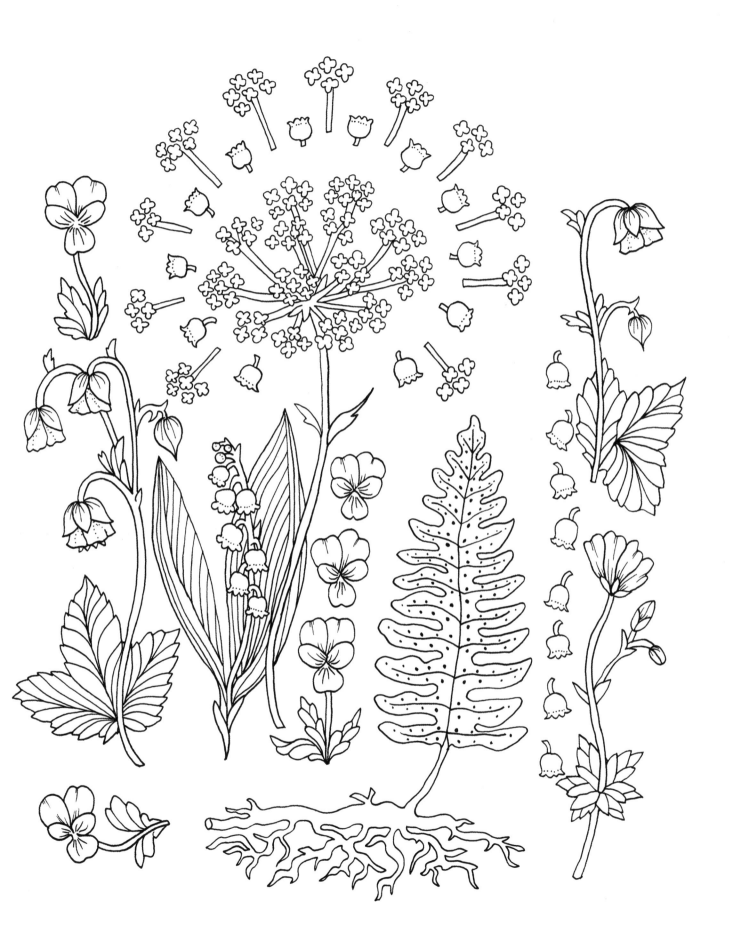

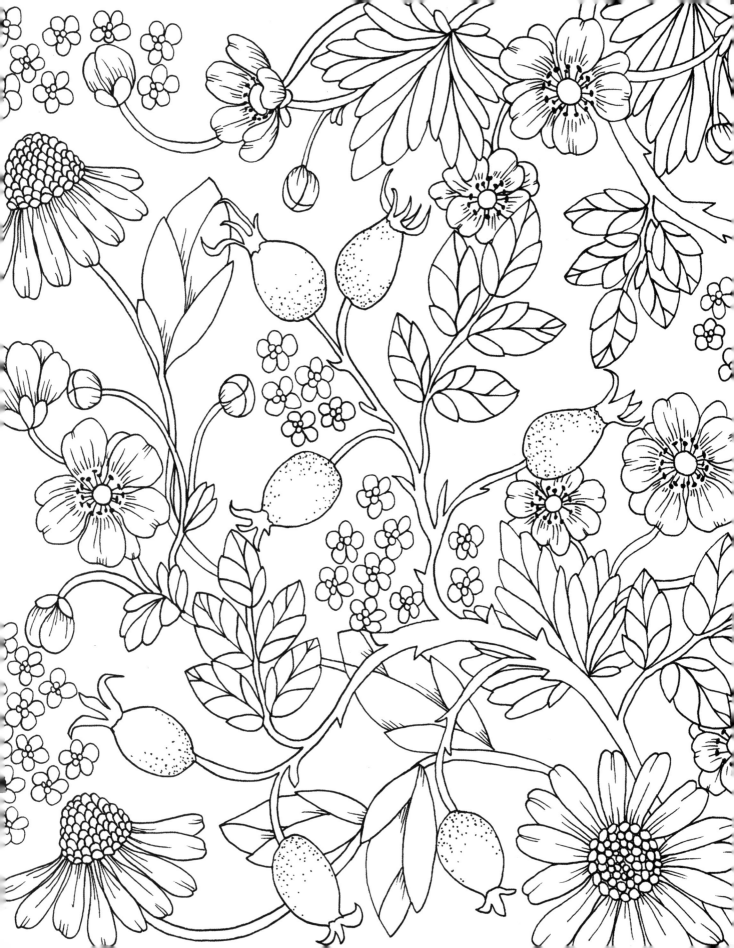

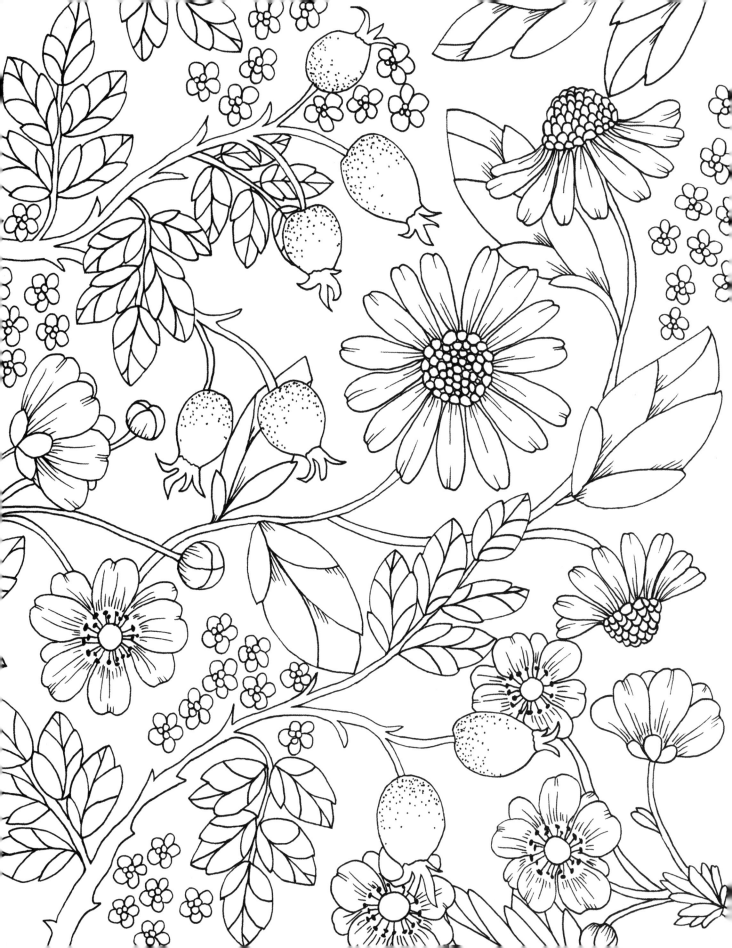

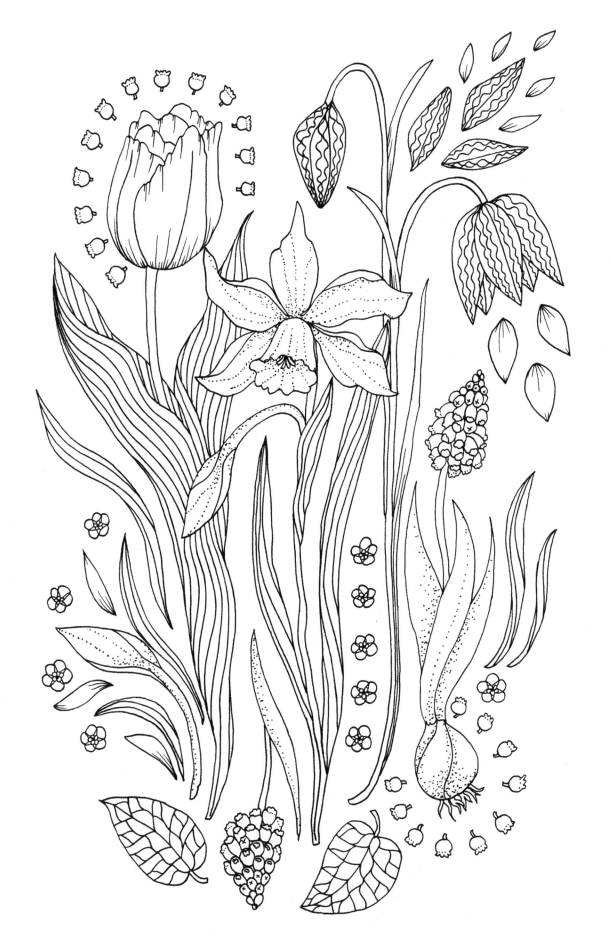

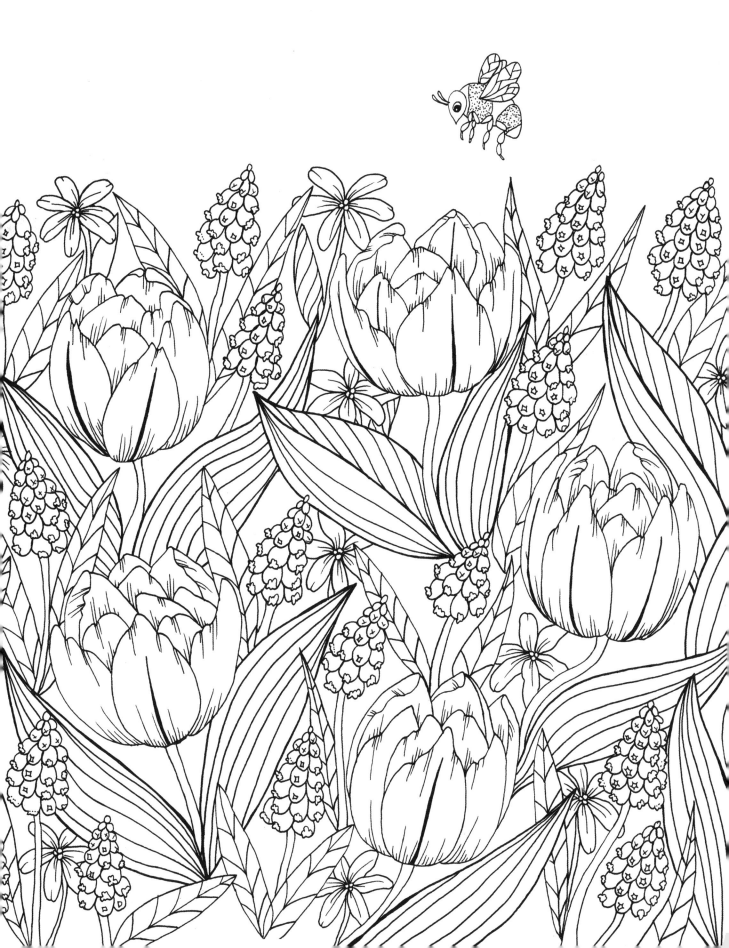

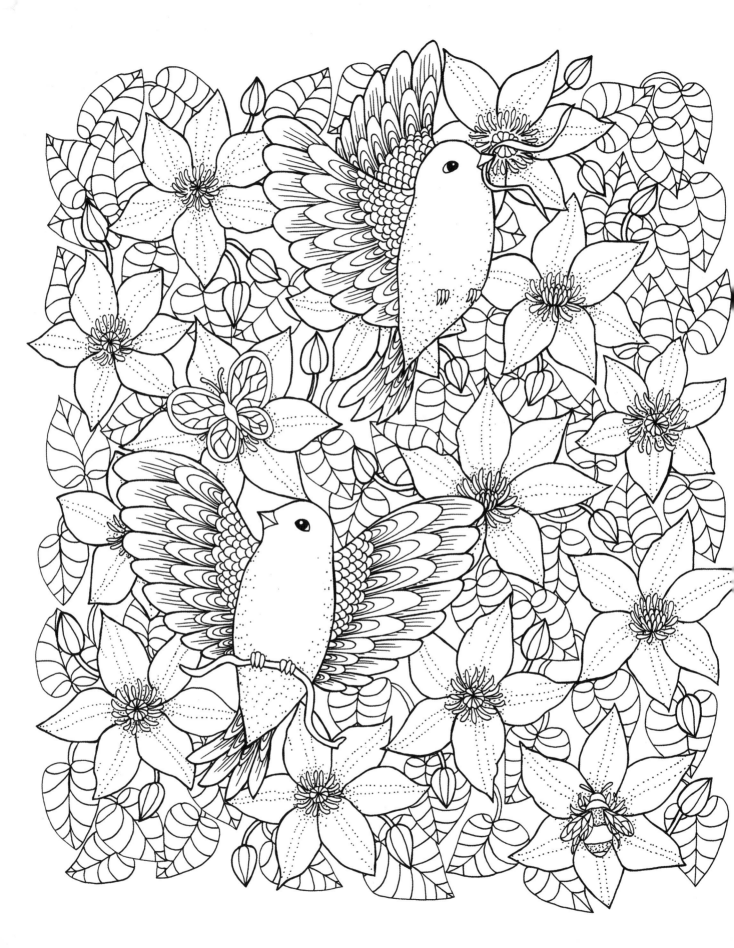

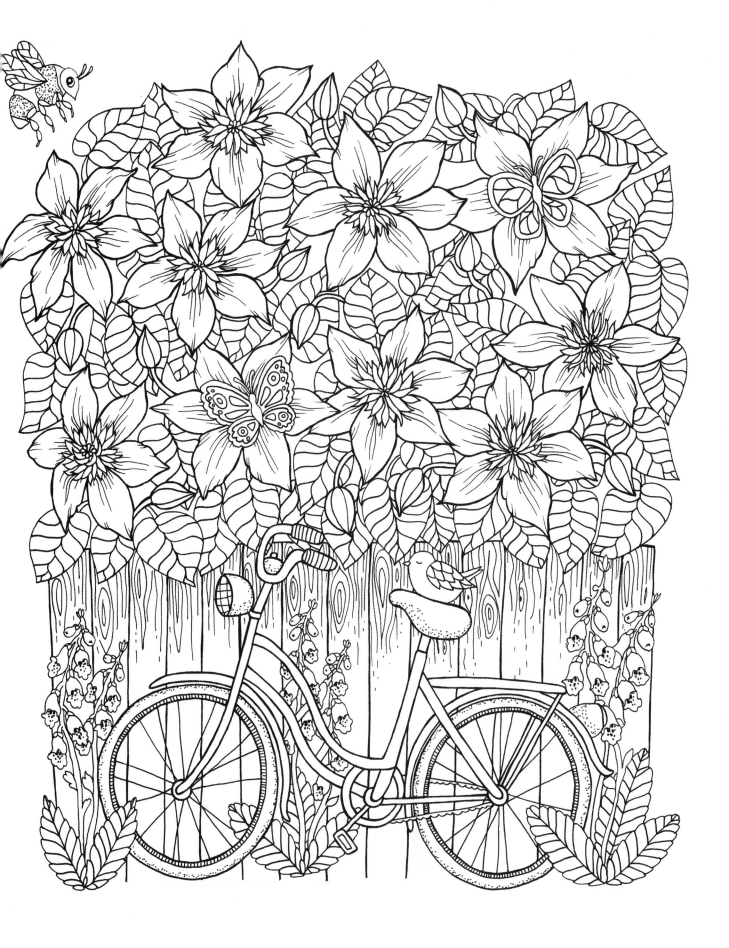

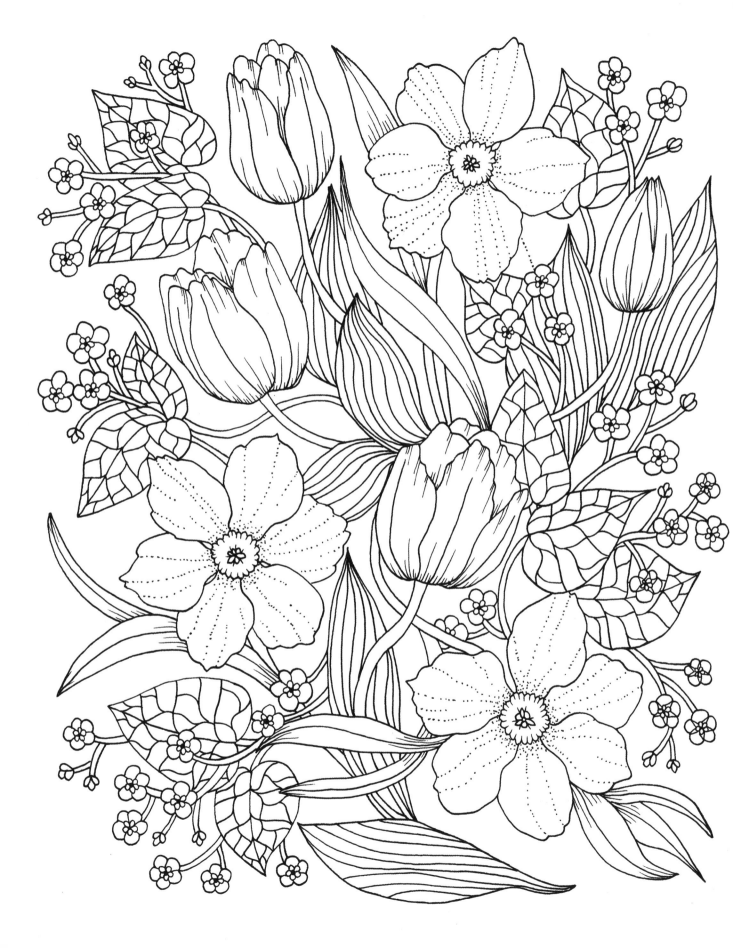

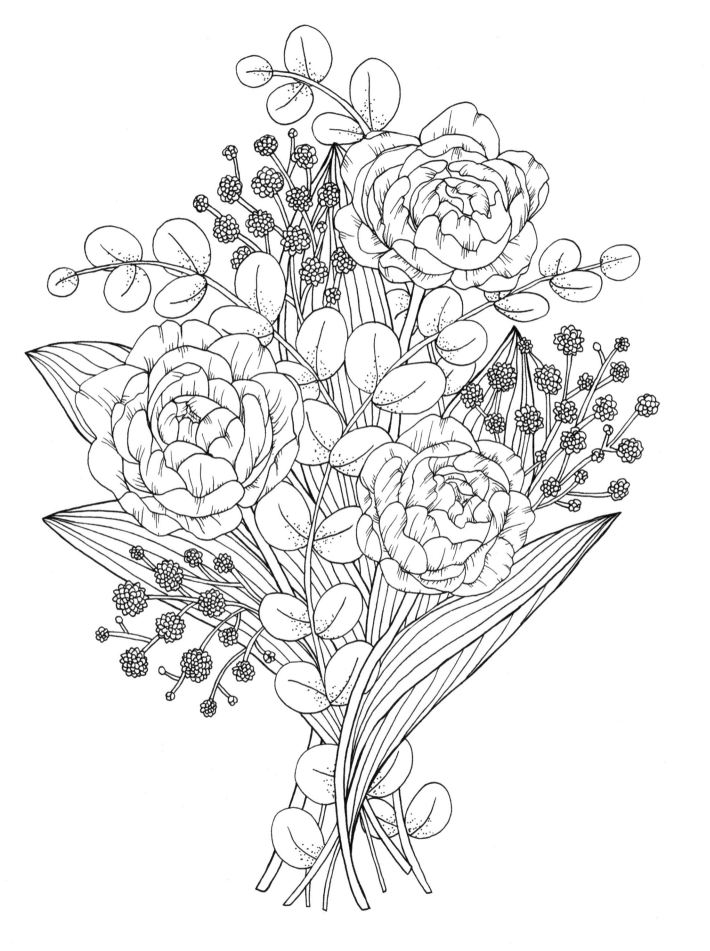

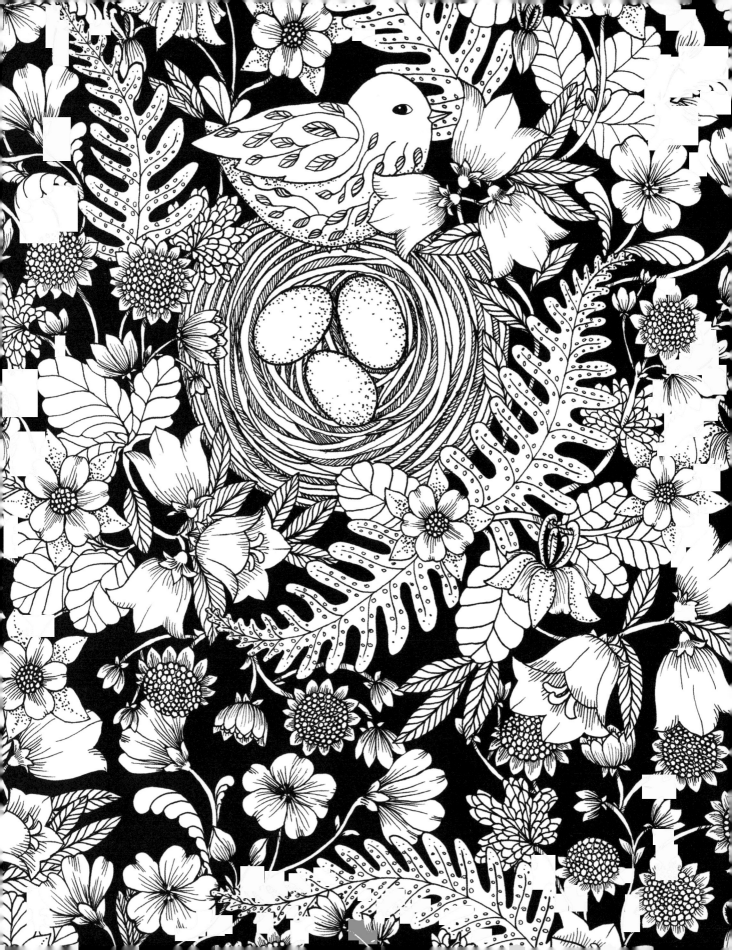

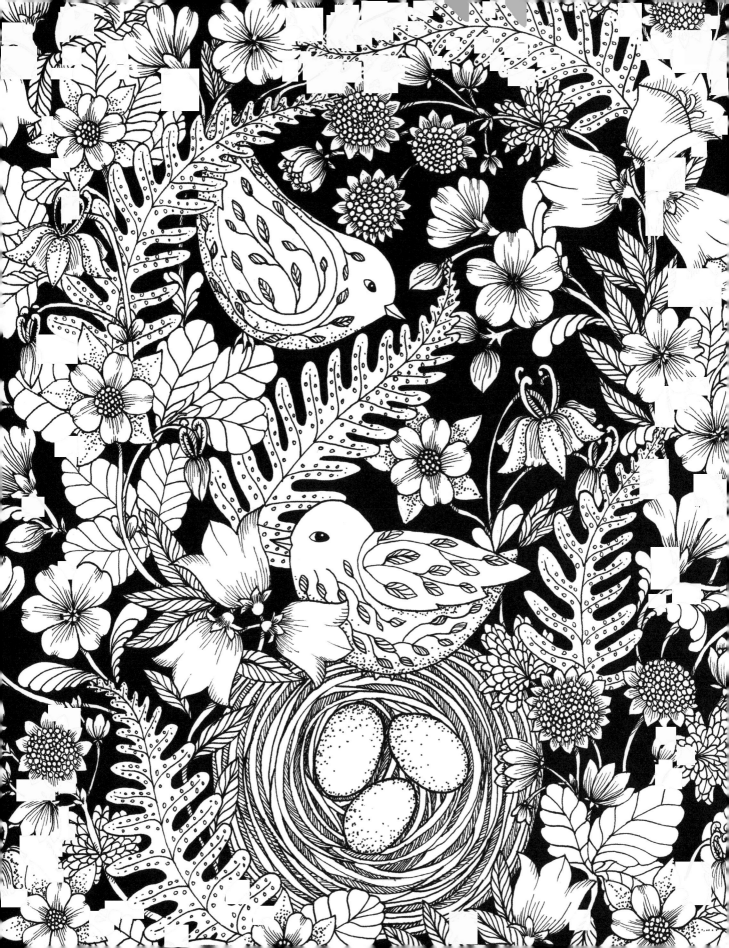

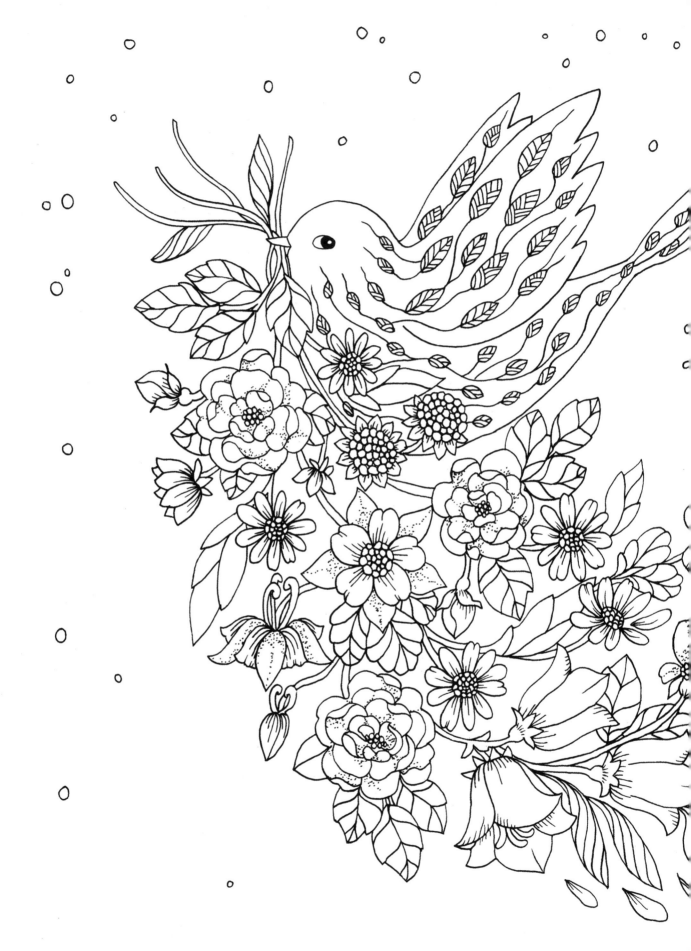

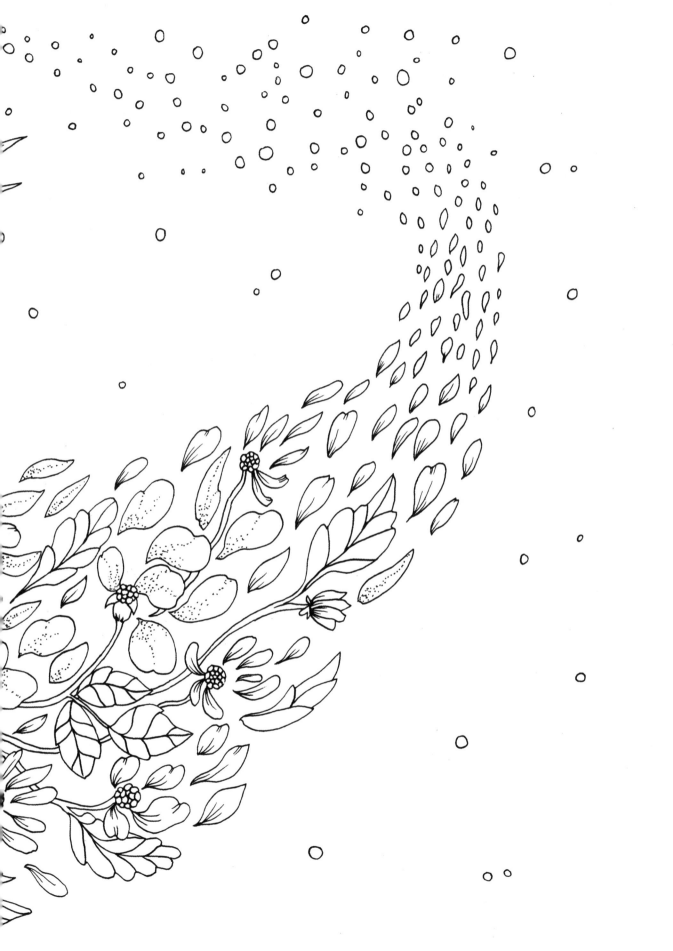

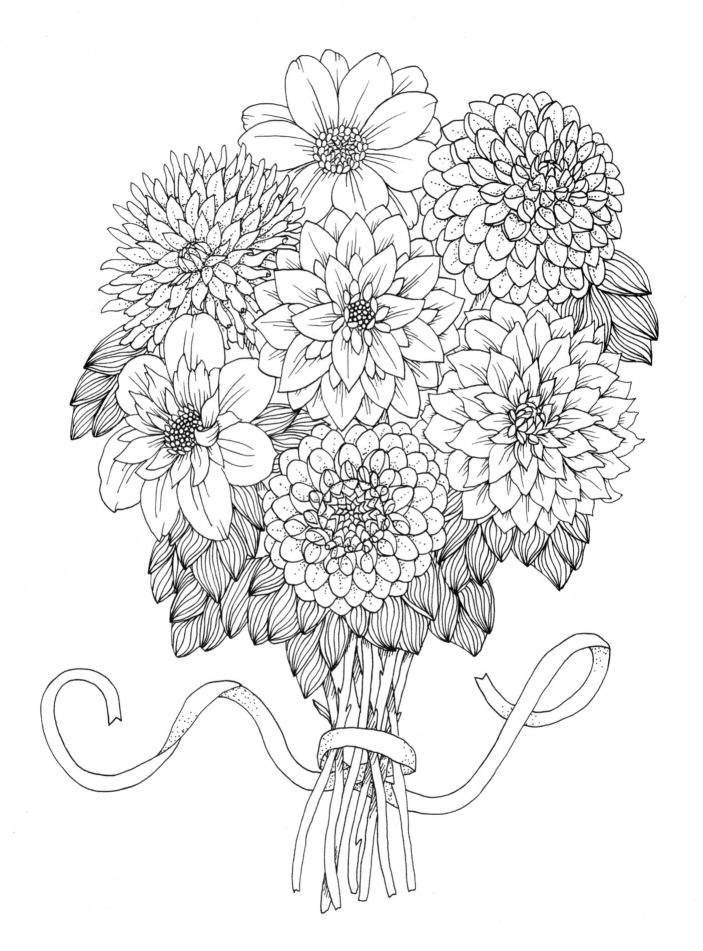